blogging for
photographers

Jolie O'Dell

blogging for photographers

Showcase your creativity
& build your audience

ILEX

First published in the UK in 2013 by

I L E X
210 High Street
Lewes
East Sussex BN7 2NS
www.ilex-press.com

Copyright © 2013 The Ilex Press Ltd

Publisher: Alastair Campbell
Associate Publisher: Adam Juniper
Creative Director: James Hollywell
Managing Editor: Natalia Price-Cabrera
Specialist Editor: Frank Gallaugher
Editor: Tara Gallagher
Editorial Assistant: Rachel Silverlight
Senior Designer: Ginny Zeal
Colour Origination: Ivy Press Reprographics

British Library Cataloguing-in-Publication Data
A catalogue record for this book is available from the British Library

ISBN: 978-1-78157-997-8

Printed and bound in China

10 9 8 7 6 5 4 3 2 1

contents

"it takes a special kind of person to maintain a photography blog"

Jolie O'Dell, your humble narrator, stress-tests an Android phone.

First, you have to be a multidisciplinary creative with the ability and desire to create beautiful images and craft written words to go along with them—be those words tutorials, stories, or introspective musings.

And you can't just be creative; you also have to be (or learn to be) a little bit technical. You've got to master blogging software and figure out how to get your many megabytes of masterpieces onto the web. In some cases, you might even end up learning a bit about web servers and basic coding skills.

In addition to creative skills and basic technical know-how, you have to be something of a marketing- or business-minded hustler. You must get online to network with your peers, and you have to always find new ways to find more readers for your blog. You might even think about using your blog to build or start a business—or make the blog a business in itself.

Also, photo blogging is not for hermits or the antisocial. You should be prepared to come face-to-face, online and perhaps even in person, with hundreds or thousands of people. The web has always been a huge community, and social media is making that facet of the internet more apparent and more accessible than ever before. And since images and the stories behind them are such a captivating part of the web, you can be assured that your work, when it is timely, relevant, interesting, and beautiful, will garner the attention and commentary of hordes of online viewers.

Photo blogging requires many skills, some learned and some innate. But most of all, it requires time. If you have a good eye and are a proficient wordsmith—and can make the time for it—you can learn everything you need to know to be a popular, profitable photo blogger.

More important than that, I think, is the pride and contentment that comes along with building a years-deep online portfolio—a living testament to your many skills and your long-standing relationships, a chronicle of your life's stories, a totem of your own humanity that shows any willing reader your soul in all its depth and color.

Whatever your goals are, have a few of them clearly defined; this will help you prioritize and make decisions as you go along. Then, if you're ready to exercise your creativity, hone your tech and marketing skills, and bare your inner self to strangers who will soon become friends, let's begin.

Setting Goals for Your Blog

First things first, it is essential for you to define your blogging goals. No one blogs just for the heck of it; those who do struggle frequently and give up soon.

▶ Ask yourself: Why am I doing this? Is the purpose of your blog to build your photography business? Are you trying to tap into the huge online network of photographers to get better connections, new ideas, and helpful advice? Are you simply looking for an audience who will understand and appreciate your work? Or perhaps you're trying to get your head around this fast-paced new medium the internet—and learn how to master it just as you've mastered other skills in your life?

▶ Whatever your goals are, be sure to attune ever design element, every image, and every post to achieving those goals. Oversharing is all too easy in the digital world, and the internet is already full of clutter and noise. If you must add your voice to the fray, do so with conviction and purpose, and never post anything that doesn't take your one step closer to your ultimate objective.

▶ And when you struggle, when life gets busy, when blogging seems hard, when readers aren't coming yet, when no one is leaving comments, having your goals in mind will give you the strength to persist. Because in blogging as in many other aspects of life, the greater part of success is always persistence!

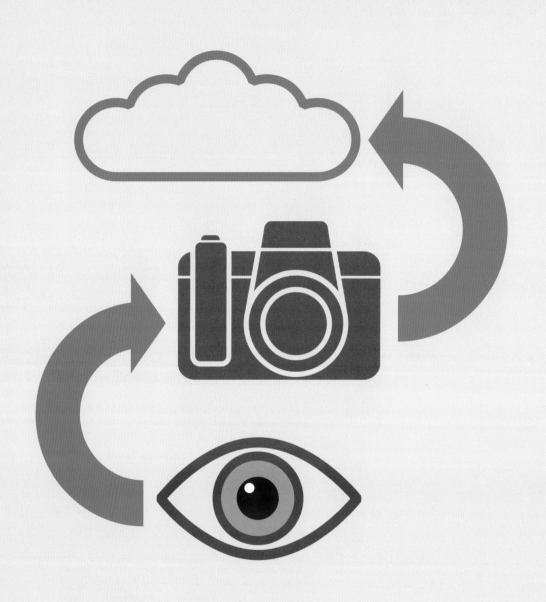

1 *basics*

Before we can get into the niceties of creative self-expression, we first have to tackle the not-so-niceties of technology.

The most basic part of blogging as a photographer is getting your images off of your camera and onto the web. You may have some experience with this already if you use sites like Facebook or Flickr. However, new options are becoming available all the time.

And a lot of the time, you may want to do some simple edits to your photos before you share them with the world. From heavy-duty photo-editing software suites to lightweight, web-based touch-up apps, you'll have a plethora of options—and as your needs vary and evolve, you may want to add more than just one to your arsenal.

One important note for anyone relatively new to the web: The images you're capturing are huge by the internet's standards. In fact, they're far too big. To be a successful photo blogger, you're going to have to get used to cutting your pics down to size—and usually, that size is going to be no wider than 1200 pixels for blogs and social media sites. If your pics are much larger than that, you're going to give your blog's readers long load times, potentially broken images, and a frustrating experience overall. In this case, smaller is better.

hardware

DIGITAL & ANALOG OPTIONS

**If you're already a photographer, let's assume you
have your own camera situation under control.**

You've probably got one or two (or a half dozen)
cameras with a lens or two (or a half dozen) to switch
out depending on your mood and the occasion. And
you've probably got your own guidelines and opinions
for selecting your cameras and lenses. This isn't a book
about photography in and of itself, so we'll skirt the
relatively thorny issues of which cameras are best for
which tasks and simply state the obvious: A digital
camera of any kind is going to be the easiest type
of camera for photo blogging.

If you're working with film, you have fewer options.
To get film images onto the web, you'll have to use or
invest in a decent quality scanner that shows color and
detail accurately. Once images are scanned, you'll want
to resize them for the web. While film is becoming a
more antiquated method, its processes and end results
are fascinating to internet audiences. Even if film is only
something you do on occasion, consider adding it
to your blogging activities as well.

If you're new to photography, start out by investing
in a decent digital camera. Pick a device that's in your
own personal price range and that won't overwhelm
you with settings and options, and get shooting!

The rest of the hardware we'll cover here will take
your pics from your camera to a much wider audience
on the web.

WIFI CAMERAS

The chasm between smartphones and high-end digital cameras is gradually narrowing.

One option is taking pictures with a WiFi-enabled camera. These bad boys shorten the line between Point A (taking a picture) and Point B (blogging about a picture) considerably by getting your images online straightaway. The cameras themselves connect to the web the same way a laptop does—by connecting to a wireless network.

With these devices, you can send your snaps directly to the social network(s), photo storage site(s), or blog(s) of your choice. You can also choose to send your images from the WiFi camera directly to another device, such as your computer.

In some cases, this means you'll have to use a login and password to get online. A shaky web connection, such as you might find at a hotel or a busy cafe, might mean longer or failed image uploads.

Some WiFi cameras will let you upload all your images automatically; with others, you can pick and choose from among your shots, then upload them with the click of a button. Photos can be uploaded with location data, date information, and even camera data.

You can also choose to delete photos as they're uploaded, meaning your camera's SD card will never fill up. Battery life can be a problem with these models. Samsung, Canon, and almost all other major camera manufacturers sell WiFi cameras in a reasonable range of prices, from a couple hundred dollars to thousands of dollars, with varying quality both of the product and of the resulting images.

The difference between a phone and a compact camera gets less meaningful every day. Indeed, with the Samsung galaxy phone you even get 3 and 4G connectivity, along with an optical zoom lens.

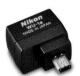

The more traditional (and bigger) camera models have started addressing the connectivity issue through the use of accessories. These two devices can be plugged into accessory ports on a range of different cameras to offer either bluebooth (for Olympus) or WiFi (for Nikon) connectivity.

WIFI SD CARDS

Broadcast a WiFi signal from the card itself!

If a WiFi camera isn't in your price range or of sufficient image quality, but you still want the convenience, you might consider getting an SD card that has WiFi capabilities. These cards will fit into most new camera's SD storage slot, but they bring WiFi radio capabilities that allow an ordinary camera to gain access to nearby devices, including web networks.

As with the WiFi cameras, you can send your images to a computer, and you can choose to automatically empty the card as images are uploaded. And of course, these cards also allow you to choose from among many websites and social networks when you're sharing your images with the web.

WiFi SD cards bring along the same pitfalls as WiFi cameras: possible failed uploads, network login hurdles, etc. Also, since the cameras themselves don't have the same inputs and menu options as a WiFi camera, you'll have to set up the WiFi SD card's internet access options yourself, including network names and passwords for a limited number of networks.

WiFi SD Cards are clearly a stopgap while we wait for camera manufacturers to become full connected, but they work well in certain scenarios—particularly if you don't need to upload a Raw files directly to the internet. HINT: *you probably hardly ever need to do this!*

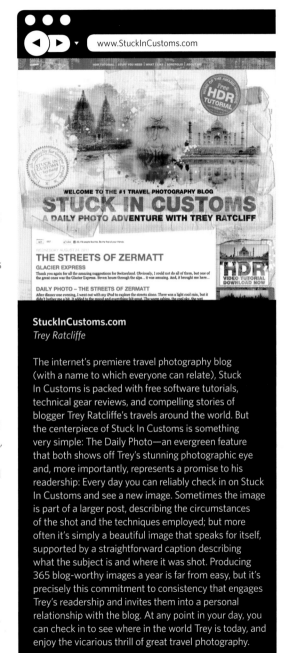

StuckInCustoms.com
Trey Ratcliffe

The internet's premiere travel photography blog (with a name to which everyone can relate), Stuck In Customs is packed with free software tutorials, technical gear reviews, and compelling stories of blogger Trey Ratcliffe's travels around the world. But the centerpiece of Stuck In Customs is something very simple: The Daily Photo—an evergreen feature that both shows off Trey's stunning photographic eye and, more importantly, represents a promise to his readership: Every day you can reliably check in on Stuck In Customs and see a new image. Sometimes the image is part of a larger post, describing the circumstances of the shot and the techniques employed; but more often it's simply a beautiful image that speaks for itself, supported by a straightforward caption describing what the subject is and where it was shot. Producing 365 blog-worthy images a year is far from easy, but it's precisely this commitment to consistency that engages Trey's readership and invites them into a personal relationship with the blog. At any point in your day, you can check in to see where in the world Trey is today, and enjoy the vicarious thrill of great travel photography.

CABLES, CARDS, & COMPUTERS

Show me a photographer's workspace, and I'll show you bundles of tangled-up connection cords and chargers. But it doesn't have to be that way!

If you're not taking your images directly from your camera to the web, you'll need to get your pics off the camera and onto another web-connected device. Given image sizes and device connectivity options, a tablet is probably not your best bet for getting your images onto the web.

If you're using an old-school desktop computer with a hard-wired web connection, you may have all the horsepower you need to transfer, edit, and upload your images. If your machine or connection are slow, however, you might be facing some extra obstacles, if only due to the fact that high-quality digital images can

be very large. If speed is a concern, look into hardware and connection upgrades and save yourself hours of desk-banging and frustrated muttering to yourself.

The same rule applies to laptops: If your machine is slow and you plan on taking your digital photography and photo blogging seriously, look into an upgrade sooner rather than later.

As far as laptops are concerned, there's a balance between large-size screens (truly wonderful for examining and editing your work) and battery life and portability. The bigger the screen, the less time you'll have to work unplugged. And the bigger the screen,

Unless you make the effort to establish a reliable workflow for yourself, the simple task of transferring images from your camera to your computer (and the web beyond) can quickly become a mess. And it doesn't stop in the physical world—you also need to organize your virtual desktop!

Sufficiently specced, there's not much a laptop can't do—though it's worth doing the research to know exactly what your needs are before you buy.

the bulkier the bag you'll be lugging around with you to various locations—that is, if you plan on photo blogging while you travel.

These days, laptops are getting thinner, lighter, and more energy efficient all the time. Newer "ultrabooks" and their ilk—15- to 13-inch laptops with astoundingly long battery life and display quality, such as the MacBook Air—often also have SD card-reading slots and can be a boon to the on-the-go photo blogger.

You've got several options for getting your pics from a camera to a computer. Depending on your hardware, your camera might be able to connect to your computer directly through a USB cable. Or, you might be able to remove your SD card and pop it into your laptop's SD card reader. If your computer doesn't have an SD card slot, you can purchase an SD-to-USB adapter from any computer or camera store.

Once you've dragged and dropped your pics from your SD card to the folder of your choice, delete them from the SD card and get it back into your camera. Make sure you keep your photo-holding file folders on your computer well-organized and thoroughly pruned; those big images can eat up space on your hard drive fast, and need to be backed up in at least one location.

mobile photo blogging

A CAMERA IN YOUR POCKET

*"The best camera is the one
that's with you."*

With very few exceptions, even high-end cameraphones have fixed-focal-length lenses (usually wide angle), and very small sensors (not good in low light).

The above quote from Chase Jarvis is especially applicable to photo bloggers. No matter where you go or what you're doing, it is quite conceivable that you might come upon something beautiful, unusual, interesting, or poignant, whether or not your have your state-of-the-art DSLR on hand. In those moments, do not hesitate to whip out your iPhone, Android, Windows Phone, or BlackBerry, and snap away.

Mobile photography carries its own set of limitations. You'll be working with an underpowered camera and lens, and your images won't have the same sense of perspective. The way a mobile phone camera captures light is a lot more limiting than we'd like. All things considered, a smartphone's camera is not an ideal tool. Still, it can be a very handy appliance to have around, whether you're just taking pics for fun or capturing a moment of photojournalistic significance.

As a side note, in my day job as a journalist, I am seeing more and more powerful smartphone-generated images in the news these days, simply because the people who are making and seeing the news happen to be carrying smartphones with them at the time.

I recently wrote a whole book on the art and science of Android smartphone photography, and I got to work with skilled, professional photographers around the world who chose to put a little time and effort into smartphone photography, as well. What I learned from them is that if you use the basic principles of composition, exploit the high-quality photo apps, and edit with a light hand, you can actually turn out some lovely results that, especially to an internet audience, can carry just as much weight as the "real" thing.

If you get really into mobile photography, you can look into higher megapixel cameraphones, high-end camera apps, quirky techniques and photo-sharing sites specifically for that medium, and even hardware accessories to perfect your mobile photography, including lens add-ons and miniature tripods.

The trick is to make the most of the camera, and to learn to exploit its quirks for what they are, rather than scoff at their relative inferiority.

If you're into the idea of mobile photography, you'll want to start out with a smartphone—Android, iPhone, or Windows Phone—that has a decent camera. Check out online reviews, and don't be fooled into thinking that a higher megapixel count automatically means you'll get better photos. Search around on the web for side-by-side comparisons of photos taken using the same scenery and the same lighting and two different smartphones. Most importantly, always make your decisions based on data and facts, not marketing and hype. The right camera phone for you may not come in the package you expect, so keep an open mind.

Once you've got the smartphone/minicamera of your dreams, if you plan on making mobile photography a significant part of your online work, you can invest a little here and there in accessories. Smartphone-specific tripods will allow your mobile device to get a grip on whatever immobile object is most convenient (and is especially useful for shooting movies). You'll also find clip-on lenses for shooting fisheye and wide-angle shots, filters for lending more authentic effects to your shots, cases to give you a better grip, and even shutter hardware options.

A few pointers on mobile phone photography:

▶ You can't control much—lighting, aperture, shutter speed—so control the composition. Pay special attention to perspective, proportions, etc.

▶ Low light is especially troublesome for mobile photographers; avoid it at all costs if you want to avoid capturing blurry, ugly images.

▶ Macro images and close-up portraiture can be stunning with a mobile phone. Landscapes, on the other hand, are much more difficult.

▶ Ease up on the Instagram! Overly filtered, hipster-ized photos don't look artistic; they look amateurish. Use a light hand when editing, and use specialty effects such as tilt-shift conservatively.

▶ Use only high-quality photo apps. Avoid free apps—in mobile photography as in life, you get what you pay for. Try Camera+ on iPhone and Vignette on Android.

▶ Use social media apps to share out your mobile snaps. Even if these quick pics aren't worthy of a full blog post, on Facebook, Twitter, and Google+, your "work of a moment" will shine and be appreciated by friends and fans.

▶ The web is flooded with mediocre snaps of fancy dishes and drinks. Before you shoot and share, ask yourself what your food shot brings to the table.

▶ Think twice before you share images on a location-based service or add location information to a photo you're sharing in real time. Particularly if you're photographing other people, giving a public audience information about where you are right now might not be the safest or most private option.

▶ Don't overshare! Try to limit your photo-shares on social media sites to one per day.

▶ You are your own most available model, but keep your ego (or appearance of ego) in check by limiting your self-portraiture to a bare minimum.

17

photoshop & alternatives

Everyone has an opinion on image editing, and it's an easy place to get carried away. But learning at least the basics will invariably help your images.

Even the best photographers need a little help on the software side, whether it's a simple crop or brightness adjustment, or more serious corrections to fix busted hues and exposures.

It goes without saying these days that Adobe Photoshop is hands-down the best photo-editing tool for the photo blogger. While it does take some practice to learn to use Photoshop correctly, the results are well worth every ounce of effort. Still, Photoshop has its downsides: It's a huge piece of software that, along with the files it creates, can cramp smaller hard drives.

But the most common complaint anyone has about Photoshop is its expense.

This software will cost you hundreds of dollars— and you'll have to pay a couple hundred more each time Adobe issues a new release and you want to upgrade. Adobe knows it's the absolute best software on the market for this kind of image-editing, and prices it accordingly.

If you can afford Photoshop and are serious about photo blogging or photography in general, make the investment. You can try the software free for 30 days,

Gimp looks a lot like Photoshop on the surface, and can perform a lot of the same tasks—you will just have to learn its workflow.

18

and all kinds of tutorials and help are available online free of charge. Whatever you do, don't pirate this or any other software. Especially if you're a professional, it's not only immoral and illegal; it's tacky.

If you simply can't afford to buy a Photoshop license, don't despair. Lots of alternatives do exist, from full-featured Photoshop clones to lightweight apps you can use on the web. Some require as much as or more skill than Photoshop to maneuver and use correctly; others are as simple to use as the click of a button.

Gimp is an free and open-source image editing software that has long been used by a dedicated community of enthusiasts. Its interface is quite different from Photoshop, and its learning curve is significant. However, you can't beat the low, low price of free.

Because software evolves so rapidly these days, you should do a web search to find out what the best-quality free Photoshop alternatives are. New programs are made available every year, and these products get better and better all the time.

Some photo websites will have their own built-in tools for simple editing. For example, on Flickr, you can use robust photo-editing tools from Aviary to do everything from cropping and brightening to adding complex filters and retouching facial blemishes and yellow teeth.

And depending on the kind of hardware you're using to capture images, you may have built-in editing tools there, as well. These tools may include cropping, red-eye correction, exposure adjustment, and in some of the more cutting-edge models, even the ability to choose a point of focus and adjust the depth of field on the fly.

Again, as hardware and software are both rapidly evolving, you will have more and more opportunities to use available technology to ensure your images are as beautiful and accurate as possible. My only caution about photo-editing software is this: Don't forget there's often a big difference between a highly edited photograph and a good photograph—and don't ask your blog readers to believe an edited photo is necessarily a good photo, either.

No matter what tools you choose to use, be sure to search the web for tips, help, and tutorials to make your final products as professional as possible and to avoid any rookie mistakes.

Most of the big photo-sharing sites, like Flickr, have some degree of editing built-in, and can even perform those edits to uploaded photos.

19

SPECIAL NOTE ON IMAGE SIZES FOR THE WEB

It may seem tragic to throw away all those precious pixels, but you will be doing yourself—and your readers—a big favor.

As previously mentioned, the web doesn't favor large image sizes—not as large as the ones your camera can capture, that's certain. When it comes to using social media sites and blogging sites, you will never need to show an image wider than 1200 pixels, and in fact, uploading images larger than that can hurt your blog's performance and page-loading speeds.

If you're using Photoshop or a similar program, save your images with a pixel density of 72 ppi, and check the image size and estimated upload time in the program's Save for Web dialog.

If you're uploading to a photo-hosting site such as Flickr, feel free to upload the largest size you have; the service will resize the image for you in several web-friendly options. For example, if you upload a 4000-pixel-wide image, Flickr will store the huge original size, as well as large (1024-pixel wide), medium (640- and 500-pixel wide), small (320- and 240-pixel wide), and thumbnail sizes. You can then use the URL or image file from one of the medium or large photos to continue blogging with the image.

There will be occasions when you want to show a particular part of the image at full scale. In those circumstances, save a version of the original image in a web-friendly size, then crop the original to show the detail in a similarly web-friendly size. You can then use both smaller images on your blog.

As far as file formats are concerned, for blogging purposes, you're never going to need the Raw files your camera might capture. Only JPEGs will be useful in photo blogging. Even GIF and PNG files are not going to be as useful as JPEGs, if only because it will be easier for you and your readers to share and promote your photos via social media if those images are JPEGs; some social networks handle other image file formats rather poorly.

The Save for Web dialog has loads of options to help optimize your photo for blogging purposes—besides resizing, you can also check its color profile settings, and even see a before/after preview to make sure the tones and contrast are holding up

2 blogging platforms

Once you have your hardware and software for capturing images and getting them onto the web, it's time to decide where those images are going to go. For a photo blogger, this means you'll have to choose a blog software, known as a content management system (CMS).

Your CMS will allow you to pick (and switch) themes, colors, fonts, and layouts to allow you to build a creative and individualistic website. When it comes to creating posts, you'll use the CMS to upload your photos and add text to accompany them, from simple captions to thorough explanations of technique.

While a lot of blogging software is free to use, you can also choose to pay for premium features, such as more sophisticated visual themes or custom URLs (that's the website address for your blog).

Like Photoshop is the de facto software for image editing, WordPress is largely the de facto software for blogging. There are other CMSes, but WordPress is the workhorse of the web, the most popular blogging software on the internet, and the one I easily recommend.

themes & templates

WORDPRESS, TUMBLR, BLOGGER, & MORE!

The design of your blog is one of the most important and exciting parts of the whole enterprise.

When choosing a pre-made design, or theme, for your blog, keep in mind that the photography should be front and center in the minds of your readers.

Look for themes that showcase images in a slider format or that feature magazine-like layouts. Most importantly, make sure your in-post images will have enough space to shine. If the blog theme only allows for a maximum 500-pixel width on images inside blog posts, you should keep shopping around.

With any out-of-the-box theme, try to find areas you can customize, whether it's typography, colors, or the blog header (the image that runs across the top of many blog websites). The last thing you want is for your blog to look exactly like another photographer's blog; it's as bad as showing up at a party wearing the same dress as someone else.

Even off-the-shelf designs usually facilitate some degree of customizability, which you should make use of in order to make your blog stand out.

WORDPRESS THEMES

If you choose to run a WordPress blog, your theme choices will change depending on whether you run a self-hosted WordPress blog or a WordPress.com blog. Let's break down what that means.

A WordPress.com blog is a plug-and-play experience. You choose your blog name, pick a theme, and start blogging right away—no hassles, no muddling around with web servers, no setup whatsoever. For the less technically inclined, a WordPress.com blog is a great way to quickly and easily get started as a blogger. If you'd like a more professional touch, you can always buy your own URL (domain name or website address) from a registrar like NameCheap or GoDaddy and make your WordPress.com blog live at that address. The theme choices for a WordPress.com are somewhat limited, but you'll be able to get along just fine in most cases.

However, if the idea of downloading the actual WordPress software from WordPress.org and running it on your own web server doesn't sound too intimidating, a self-hosted blog gives you many more options. With a self-hosted blog, you can run ads and widgets, and you can sample from an endless smorgasbord of themes, both paid and free.

We won't get into the how-to of setting up and running a self-hosted blog here; you'll want to do a bit of research on the web before you commit to a self-hosted blog. The software from WordPress.org is free, but the hosting can cost a lot in terms of time and responsibility on your own part.

Here are ten themes, both free and paid, for WordPress.com blogs. All are ideal for photography, but each one has a different look, unique special features, and customization options.

Triton Lite

Price: Free
Features: *Image slider for the homepage, super slick rollover interactions to make your photos pop*

Autofocus

Price: Free
Features: *Bare-bones but gorgeous layout that puts your pictures front and center, up to 800 pixels wide*

You'll be able to pick out a theme when you start setting up your own blog at WordPress.com. If you want to change the theme, you're free to do so at any time. From your blog's dashboard, just scroll down to the Appearance button in the left column, then click Themes. To find any of the themes listed here, just do a search from that page.

Suburbia

Price: Free
Features: *Custom header and background with a minimalistic magazine layout and lots of widget space*

Structure

Price: Free
Features: *Featured post, featured images, and widgets galore*

On Demand

Price: Premium
Features: *Top slider; compact thumbnails to show off your work*

Portfolio

Price: Premium
Features: *Really, really large images displayed on a clean, white background; featured posts*

Wu Wei

Price: Free

Features: *Images up to 700 pixels wide; complete simplicity*

Linen

Price: Premium

Features: *Homepage slider; full-width pages*

Forever

Price: Free

Features: *1000 pixel-wide homepage slider; featured posts; custom colors, header, and background*

Ideation & Intent

Price: Free

Features: *A main image and a slew of thumbnails for each post, plus a column that highlights all the photos you've posted lately*

TUMBLR THEMES

Tumblr is best suited to microblogging—quick updates with pithy commentary and colorful images. Less robust and professional, but very easy to use.

Tumblr will give you lightweight tools for simple blogging from the web or your mobile phone, and it comes with built-in social features for promoting your work elsewhere online. The Tumblr community itself it currently quite robust and can deliver like-minded readers and lots of exposure for your photography if you put time and effort into your photo blogging and the Tumblr ecosystem.

However, while Tumblr might be a good place to begin and get your feet wet with photo blogging, it's likely not the right platform if you're a professional photographer or a serious amateur, if you're trying to build a business around your photography, if you're looking for a lot of conversation around your work, if you're looking to dominate search engines, et cetera.

If you are a seasoned pro at blogging, Tumblr can give you a great secondary place to show off images that might not make the cut for your main blog but that people find entertaining, interesting, or inspirational.

Tumblr themes are also a good option for mobile photo blogging, and you might find this platform plays nicely with Instagram or other popular mobile photography apps you use. Tumblr itself also provides a mobile app for photo blogging on the go.

Here are a handful of Tumblr themes particularly well-suited to photo blogging. You can find them in your Tumblr blog's Customize menu, or you can search for them online.

The Atlantic

Price: Free
Features: *A clean, classic layout with plenty of visual space for your photos to shine*

Hd Exhibit

Price: Free
Features: *Nearly full-width photos and pretty galleries; very little distraction from your gorgeous pics*

Venice

Price: Premium
Features: *Huge photos up to 1000 pixels wide; color and font customizations; and a groovy grid layout for multi-photo posts*

SYNDEX

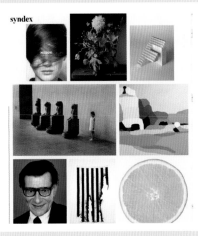

Price: Free
Features: *A moodboard-style theme featuring lightboxing and infinite scrolling; looks particularly great on tablets and other mobile devices*

Metropolis

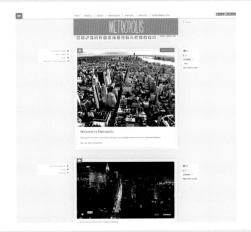

Price: Free
Features: *Big photos; lots of customization options; Instagram integration; and sticky and featured posts—a rarity in Tumblr themes*

Candor

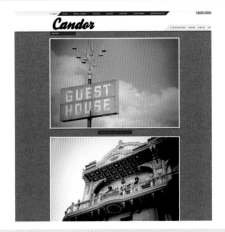

Price: Budget
Features: *Big, hi-res photos; sticky and featured posts; support for a wide variety of fonts*

BLOGGER TEMPLATES

If you don't feel inclined to use WordPress or Tumblr, or if you prefer to use a Google-integrated product, there's also Blogger, Google's own blogging software.

Blogger works particularly well with Google+, the parent company's social network. And since Google+ has proven to be quite the stomping grounds for successful photographers, a Blogger blog isn't such a terrible idea.

Blogger's officially sanctioned templates are far fewer in number than you'd find in other web-based CMSes; however, with a few customizations, a few of them can be good for photo blogging. The Blogger template Dynamic Views is highly customizable and allows for magazine, mosaic, and snapshot views, any of which are suitable for displaying images.

However, to make the Blogger templates ideal rather than just suitable takes a bit of tweaking and a lot of time. You can change column widths, colors, backgrounds, and typography to achieve a more unique, pleasing design for your blog.

If that sounds like heavy lifting, you might try searching the web for dedicated Blogger templates for photography. Outside of Blogger.com, you can find third-party online marketplaces full of Blogger themes that you can download and then upload to your Blogger blog. These marketplaces aren't run by Google, and as a result, the quality can vary widely. Still, many great templates are available, and we'll showcase a couple of them here.

To upload a new template to your Blogger blog, login to Blogger.com, and on the Template page, click the Backup/Restore button in the top right corner. Then you'll be able to upload the .XML file for your new template; this file may be located inside a .ZIP file that you downloaded from the web.

Whatever template you choose will likely have a few must-read customization options, so search the web to find helpful hints and guidance from the template designer themself.

In addition to the templates shown above, be sure to search the web to find more recent themes that suit you personally.

Madkassar

Price: Free
Features: *A four-column gallery, free from sidebars; each thumbnail has a scrollover animation for text*

Lightroom

Price: Free
Features: *Another gallery-style template that showcases scannable thumbnails of your most recently posted images*

CUSTOM OPTIONS FOR THE TRUE PROFESSIONAL

If this isn't your first rodeo, so to speak, you may consider foregoing the free software route in favor of a truly bespoke solution.

Many web design shops and portfolio software companies can turn out beautiful websites and blogs for the professional photographer. If photography is your business and if you don't want to get your hands dirty with endless tweaking and customizations yourself, this might be the best option for you.

Prices will vary, but as in every other aspect of life, you get what you pay for. Higher-dollar services will combine custom designs and IT support, leaving you blissfully free of all that troublesome HTML and CSS, not to speak of web hosting and custom URLs.

If you choose this path, expect to pay a couple to a few hundred dollars to have your site and blog set up for you with a template design. For a custom design, you'll have to throw more money at the problem—and at a professional web designer/developer.

Every year, many small businesses with a handful of designers and web developers set up shop to do web design. One such shop is ProPhoto, which gives you technical support and photo-perfect themes with a tiered pricing system. ProPhoto's themes are built with WordPress and require a self-hosted WordPress install, for which ProPhoto provides online tutorials.

You can also choose to work with a freelance web designer. Be sure whomever you choose has specific experience with blogging software and will leave you with an easy-to-use CMS that you can continue to maintain yourself.

One of the best ways to find the perfect person or people to design your blog and website is to scroll to the very bottom of photo blogs you admire. Often, the blogs will contain a link or two at the bottom of the page saying who designed the site and what software they used. Use these links as signposts to guide you to a good professional and as recommendations of that person's or company's work.

The ability to work with a professional designer that can create something that reflects your personal style is an excellent way to make your blog stand out.

post layout, typography, & finishing touches

While setting up your blog, you'll likely have the option to customize quite a few elements within your chosen theme or template, such as the header that appears at the top of your blog's main page or the image or texture that appears in the background of each page.

The colors and images you use are largely a matter of your own personal discretion and taste. As long as the general color scheme and design are consistent throughout all elements and pages, you're good to go.

Typography, however, can be a bit more tricky. Over the past couple years in particular, web fonts have grown significantly in number and quality. However, not all typefaces can be rendered well and consistently across all web browsers and blogging software; there's a lot of technical nuance involved in that side of web design.

So my advice to you, the new photo blogger, is to keep it simple. For the running test of your blog posts and headlines, use typefaces that are easy to read and that don't create a distraction. If you eye ever stumbles over a word or if the typeface is the first thing you notice about the page, then you may have erred toward an overly "creative" font. Choose something plain and legible, and let your photography and writing style provide the creativity.

Another important visual element of your new blog is the layout of the posts themselves. Take some time to kick the tires of your new CMS, and see what layout options are available. Can you make a post with a gallery inside it? Can you align smaller images to the left, right, or center of the post?

Also, within the CMS new post page, figure out how to create sub-headlines, bulleted lists, numbered lists, and italic and bold text. These tips and tricks can help a lot when your post runs long or needs some visual organization.

While you're in the new post page of your blog CMS, check out the different modes for writing and editing posts. Generally speaking, you'll have a "visual" mode and an HTML mode. The visual mode will basically show you what your post will look like before you publish it. This is the best way to write and edit posts as a beginner blogger.

However, when you get your feet wet or if you've done a bit of blogging before, try editing in HTML mode. This will show you the code that's getting rendered to display your posts. If you learn a few of the HTML tags for displaying images and formatting text, you can much more accurately "tell" your CMS exactly what you want your finished post to look like. And the more control you have over each post's formatting and layout, the better.

The web is full of simple HTML guides; between web searches and some careful reading of the HTML in your existing posts, you should be able to pick up enough knowledge to be a better blogger in short order.

Later, we'll talk about advanced techniques for post layout based on the type of content you blog about.

Attention-grabbing heading

RATES

CONNECT

SHOP/FREEBIES

ABOUT

CONTACT

PORTFOLIO

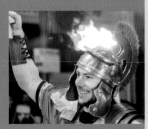

HEADING FOR THE BODY TEXT, CLARIFYING THE MAIN HEADING ABOVE

This is the introductory body text, that should lead with the most important facts in your post, and explain what to expect throughout the body of the article.

• Bullet points are an excellent way to break up long, dense paragraphs

• Look at your formatting options to see what kind of bullet graphics are offered

Secondary body-text headers help with search-engine optimization, and organize the post into digestible units

Once you're down to the main body text of your post, this is where you can concern yourself less with SEO tactics and concentrate instead on getting across your personal writing style effectively. This is also the text that should have the most legible font— you will quickly find that a font that looks great as a header or a single line of text can become a jumbled, indiscernible mess when all the letters are put into a single paragraph. Experiment with various fonts for each of the elements detailed in this post, and try them with various experimental text to see which ones hold up under the widest array of possibilities. You'll also want to play around with all the various templates and formats for arranging your text on the page. Are the images at the top of this post too small for their intended effect? Do you want to place them all at the top, or intersperse them through the body of the post? Only you can answer!

sidebars, widgets, & pages

While posts are the lifeblood of your blog, there are many other elements that help round out its purpose and make it feel like a full, online presence.

Another part of your CMS is all the parts of your blog that aren't the blog posts themselves. You might have a header at the top of the page and a footer at the bottom. Your theme or template may contain more than one column, leaving room for sidebars of content on the left and/or right side of the screen.

Do some exploring in your CMS and figure out where all these non-post types of content can be edited, then play around and see what different areas look like with different kinds of content. For example, you might choose to put a picture in a sidebar, a link in the footer, and an extra-wide panoramic image in the header.

But while you're tinkering, remember that visual clutter will distract from your images and words. Use only the stuff you think you'll actually need. For example, if you're not a big Twitter user or you don't need to build up a large Twitter following from your blog, don't feel like you have to throw a Twitter widget in your sidebar just because the option is available. Or if your Flickr stream and blog posts contain pretty much the same images, don't use a Flickr widget on your blog.

Often, these sidebars can be composed of widgets—think of these as one-off digital gadgets that connect your blog to other internet services, such as Facebook, Twitter, Flickr, email, or a web-based calendar. Some widgets will allow your readers to explore your blog better through features like search, tag clouds, or drop-down category menus.

Also, you may notice that most of the blog themes and templates I've recommended are single-column designs. That was intentional; you want to give your photos the maximum possible width on a computer or mobile device screen so they can shine. While there's nothing inherently wrong with a multi-column design, it robs main-column images of width and size. Play around a bit with multi-column formats with this in mind. If you feel your content does not suffer with two or even three columns, then forge ahead.

Another type of non-post content is a page. These function a lot like regular website pages; they won't have separate, chronological posts like your blog will. Rather, they'll contain a single, static page of text or image content. Usually, these pages are listed in a menu along the top or side of the blog. While widgets can add distraction, pages are a non-distracting way to inject your blog with vital information that helps you use the blog to achieve your goals—business goals, social goals, etc.

Based on your own objectives for your blog, you can create pages to guide your readers and fulfill your own objectives. For example, you can make these pages with these targets in mind:

RATES

How much you charge for products/services

If you do professional photography, it can help to qualify your customers by including a page on pricing with specific ranges and packages. This will help to weed out the "lookie-loo" types and will ensure that those who contact you are well informed and willing to pay your prices.

ABOUT

Exposes your personality to a new audience

May or may not contain your real name and/or a self portrait. Every blog should have an About page, even if it's a simple explanation of your blog's purpose that keeps your identity totally private.

CONTACT

How to send you a private message

Essential for building a business! This page can include an email address, a web form (if your CMS makes web forms easy), or a business phone number. I strongly discourage putting personal or cell phone numbers on the internet for obvious reasons—all it takes is one disgruntled heckler, and your text messaging charges can blow up overnight.

CONNECT

Links to your other online personae

If building a bigger social/professional network is one of your goals, this page is where you can put links to your Twitter, Facebook, Flickr, or Google+ pages.

PORTFOLIO

A permanent collection of your images

This page could be a gallery or slideshow of your best work, or it could link out to a separate portfolio you've already created.

SHOP/FREEBIES

Readymade products for order or download

If you want to sell your wares online or give your internet fans a piece of your genius, you can create a simple page for selling prints, instructional materials, or other merchandise. You can also give away digital goods such as downloadable computer wallpapers, printable art or design items, or Photoshop Action sets you've created.

choosing a url & setting it up

An important decision that you need to stick by for the long haul—make sure you like your URL, because you'll be seeing it every day.

CHOOSING AND BUYING A URL

Design and layout, while extremely detail-oriented, is the relatively fun part of setting up a new blog. Especially for us creative types, the tech side can be intimidating. But truly, as someone who's now set up more blogs than I can count, the hardest part really is getting started.

Important Note for WordPress.com and Blogger.com Bloggers

Guess what? If you chose to use WordPress.com or Blogger.com to start your blog, you can buy a URL and set up hosting automatically though your CMS's dashboard.

▶ Just go to the left menu of your dashboard, all the way down to the Settings tab. In WordPress, click Domains. In Blogger, click Basic. From that page, put in the URL you want your blog to have, and your CMS will guide you through buying the URL.

▶ If you get an error message that the URL you entered isn't pointing to your CMS, this means that someone else already owns that URL and you'll have to use a different name for your blog.

All in all, obtaining your URL this way is as easy as anything on the web could ever be, and you get to skip the whole section on setting up hosting.

Think about it: Websites that help you create blogs and set up hosting accounts only make money when you're able to successfully set up your blog. And if they made it too hard, they'd lose a lot of money. As a result, once you start the blog-setup process, you'll find lots of helpful instructions along the way to help you complete your objectives—and yes, turn over your monthly pittance—in exchange for the professional services you need.

The first thing you'll want to do is think of and purchase a URL—that's your blog's website name, usually followed by a .com. When you start your blog using web-based software like WordPress, you'll begin with a URL like reginaphotography.wordpress.com, which is much too cumbersome to tell to a new acquaintance or print on a business card. If you want your blog to have even a hint of professionalism or internet savoir-faire, you'll need a better name for your site. Be sure to get your URL before you start blogging in earnest and attracting readers.

If you already have a website for your photography business (e.g., helenaportraits.com), you can choose to have your blog reside at a subdomain of your existing site. This means your blog and website URL would be pretty much the same, only your blog URL would add a prefix to your existing URL—a common setup that readers will be accustomed to. For the example above, your blog's URL could be blog.helenaportraits.com. We'll get into how you'd set that up in just a moment.

If you don't already have a website and you're starting from scratch, then it's both exciting and daunting. Like naming anything, choosing a proper URL requires careful thought and some consideration. While you can always change your blog's URL, doing so is a royal pain for a number of reasons; it's best to pick a great URL from the start and stick with it.

Photo blog URLs can be personal and direct, like MostlyLisa.com, the blog of photographer Lisa Bettany. They can be topical, like StuckInCustoms.com, the blog of travel photographer Trey Ratcliffe (see page 13). They can relate to the type of photography you'll be doing, the sort of person you are, or the kinds of activities that fill up your life and inform your art. There are nearly infinite possibilities when it comes to naming your blog. However, I can almost guarantee you that the first couple URLs you think of will already be taken. That's just the state of the web these days!

Some general guidelines for naming your URL:

▶ Don't get creative with spelling. You'll end up saying "No, that's Fauxteaux.com, F, A, U..." at every cocktail party you go to for the rest of your life.

▶ Think carefully about possible misinterpretations. ShootingKids.com could mean that you run a photography studio for portraits of children; it could mean something less savory, as well.

▶ Don't use made-up words. No one will be as amused by Schpedoinkle.com as you are, and almost no one will remember it.

▶ Avoid the .net, .biz, .us, and most URLs that don't end in .com. The .com addresses are more expensive and harder to obtain, but they're worth every cent and every brain cell you burn through trying to get a good one. They're easier to remember and have a higher value in the eyes of a search engine.

▶ Are you using the blog primarily to build your photography business? Then consider adding your location and/or the type of photography you do to the URL to make it easier for prospective clients to find you. For example, if you do wedding work in Georgia, you could try adding words like "wed," "wedding," "ATL," etc. to your URL.

▶ Shorter is better. Enough said.

▶ If you don't have a specific topic in mind, or if your primary purpose is to build your social profile and networks, consider using all or part of your name as your URL.

▶ No matter what, make sure your URL words have something to do with your blog's topic. The aforementioned StuckInCustoms.com is a fantastic blog name for a travel photographer, but it would be a lousy name for a wedding business.

▶ Avoid hyphenated URLs at all costs.

▶ Make it memorable.

While you're researching URL possibilities, do a quick search for your potential candidates using a service such as GoDaddy, NameCheap, or Network Solutions. These companies are domain registrars—they sell URLs to folks like you for a nominal annual fee. They also keeps track of what URLs are already spoken for and which are still available.

Once you find the perfect URL, do not hesitate to throw it in your digital shopping cart and make a beeline for the checkout! Waiting a day or two could make getting that URL impossible, so do act quickly.

During the checkout process, you'll be offered a slew of add-ons, such as hosting and email services. Ignore these for now, pay the annual registration fee for your URL, and you're done with the first part of the tech setup for your new blog.

SETTING UP YOUR NEW URL

The next part can be a bit more tricky. Depending on the blogging software you use and where you bought your URL, you might have a very easy time setting up your blog's hosting. Or you might have to spend some time doing research online or on the phone with a customer support person.

If you're using a web-based blogging software like WordPress.com, Blogger.com, or Tumblr.com, and you bought your URL from another registrar, you can use the registrar's DNS (domain name server) tools to point that URL back to your blog. In other words, a blog visitor could type in "AaronsAttic.com" and be taken automatically to Aaron's WordPress blog on vintage-style film photography. It avoids having to create and market a whole new URL.

Popular Extensions

✘	Bestship.com	Taken	Who is
✘	Bestshot.net	Taken	Who is
	Bestshot.org	🛒	**$4488** PREMIUM
✘	Bestshot.info	Taken	Who is
✘	Bestshot.biz	Taken	Who is
✘	Bestshot.co.uk	Taken	Who is
✘	Bestshot.in	Taken	Who is
✘	Bestshot.us	Taken	Who is
✘	Bestshot.me	Taken	Who is
	Bestshot.co	**Available**	**$22.99/yr**
✘	Bestshot.ca	Taken	Who is
	Bestshot.mobi	**Available**	**$7.99/yr**

If the URL you want is already taken, the registrar will offer you a few alternatives. For example, you might want BestShot.com; if it's already in use by someone else, the registrar might recommend using BestShot.biz, BestShot.co, MyBestShot.com, or TheBestShot.com. Be careful about choosing the registrar's next-best-thing suggestions. They might veer toward nonsensical or hard to remember, and they're also dangerously close to an already-taken URL—one that your readers might end up going to by accident.

ADDING YOUR BLOG AS A SUBDOMAIN TO AN EXISTING WEBSITE

If you already own a website, you can add your blog to your website's URL. In the earlier example, I mentioned that you could have the URL for your blog simply be blog.helenaportraits.com if you already own helenaportraits.com.

To do this, you need to use your original URL registrar to add a subdomain to your original URL. The subdomain is a prefix that goes in front of your whatever.com website URL. In most cases, the blog.whatever.com convention works best.

When you've set up your subdomain, you can use the setup instructions for a regular URL, this time pointing the nameservers for the subdomain only to your new blog.

Getting under the hood of your URL...

▶ Go to your blog's dashboard and click through to your blog's settings—specifically, to the URL/domain settings.

▶ From there, you can get the nameservers or A-record for your blog.

▶ Once you have that information (usually one to three strings of indecipherable technobabble or numbers) you'll plug those into your registrar's DNS settings.

▶ Within a few hours, your new domain will point to your existing blog!

▶ Follow your CMS's and registrar's instructions to the letter, and if you get hung up, search the web for how to use your specific registrar and your specific CMS together. Or, you can call the customer service hotline for your registrar and ask how best to point your new URL to your blog.

▶ This process is called domain mapping, and with most non-self-hosted, web-based blogs, it costs a small annual fee, which you would pay to your CMS company.

Mapping URLs and linking domains requires a bit of elbow grease, but it pays off in unifying your online presence and makes things much easier in the long run.

3 *content*

This is really the crux of the matter, isn't it? How do you create not just one interesting story or tutorial that you are confident enough to share with the world, but another one tomorrow, another one the day after that, and maintain this pace for the foreseeable future? It's intimidating, and it's okay to feel intimidated sometimes; everyone does. But once you get started and force yourself into a regular schedule, you'll be amazed at how quickly the words and images come to you. It's a matter of managing expectations, keeping organized, and confidence. What is intimidating today will be inspirational tomorrow, and eventually becomes an addictive drive to push yourself to post with skill and competency on any number of topics.

Fortunately, you're not alone—the entire internet is your support group, and also there are a number of straightforward techniques and habits you can build up to help you express yourself.

how to write a blog post

So, you've got your software selected, your tech stuff set up, your design tweaked to perfection... and a big, empty page sitting in front of you. There's nothing more daunting and writer's-block-inducing than an empty page.

Fortunately, this is a blog post you'll be writing, not a book, magazine article, or manifesto, so the first words you write aren't a make-it-or-break-it endeavor. Unlike with any other kind of medium, relatively few people will read the first words you write on a new blog; your blog readership will pick up as you go along. With your first few posts, you can write comfortably and creatively without the pressure of a huge audience.

In time you'll strike a tonal balance between keeping it casual enough that you aren't too intimidated to write your posts, and serious enough that your audience will find valuable insights in each post.

One caveat about composing blog posts: As one who blogs for a living, I highly recommend using a non-web-based text editor such as OpenOffice or Microsoft Word to compose any lengthy or in-depth blog posts, especially before you get fully acclimated to your CMS. Depending on the strength of your internet connection and myriad other factors, most CMSes will inexplicably "dump" your posts from time to time for no apparent reason. Ain't technology grand? In these cases, navigating back in the browser or refreshing the page may or may not recover your work, but to be on the safe side, it's almost always advisable to work offline first, then copy and paste the text into the CMS when you're ready for final editing. This precaution may not be necessary for shorter posts, especially when you've had a few weeks' worth of experience.

When blogging, you should always write in the first person; blogging is a uniquely personal sort of publishing. However, this isn't a diary or journal, so you'll still have to adhere to rules and norms of grammar, spelling, and structure if you want a steady audience of readers.

Beyond that, there aren't too many boundaries for what can and can't be blogged about or how you should or shouldn't write for your blog. Self-publishing online was intended to be a liberating experience, so take the following guidelines as best practices and suggestions for starting your blog off with great content that your readers will find useful.

blog.MingThein.com

MING THEIN | PHOTOGRAPHER

HOME PORTFOLIO FLICKR ABOUT & CONTACT CAMERAPEDIA! ASK A QUESTION
IPAD APP TEACHING STORE WORKSHOPS COMPETITIONS FACEBOOK ARCHIVE

About

Armed with a camera since 18, my photographic career has spanned many subjects. Photography is beyond a job for me: it's a passion.

And this means photographing the things you're passionate about in their own right – which is why I specialize in watches, food and architecture/ interiors. Every photographer aims to find a unique look to their images in order to create a signature look for their clients. I take inspiration from many sources – classical photojournalism, abstract art, motion picture and film – to deliver a unique look and style for my clients. Natural color and dynamic lighting create a strong positive emotion in the viewer, which in turn makes the subject of the photograph – your product or service – memorable. I work on location with both available light and controlled lighting, depending on the needs of the client and subject

I have a diverse international client base including Jaeger Le-Coultre, Van Cleef & Arpels, Maîtres du Temps, Richemont, the Swatch Group, Hiljas Kasturi Architects, Tango Associates Architects, Sunway Group, Maybank, Eastern & Oriental, The Boston Consulting Group, The City of London and Moon Travel Guides. I also maintain an extensive library of over 100,000 high-resolution images available to license, both directly and via Getty Images. For 5 years, I was Contributing Editor to CLICK! Magazine, Malaysia and Editor for 2010. I am also a Nikon Professional Services member in the UK.

Please do not hesitate to contact me to discuss a project, request a quote, or a specific portfolio of images.

Search this website ... Search

MING THEIN'S PHOTOGRAPHY COMPENDIUM FOR IPAD

App Store

ANNOUNCEMENTS AND NEWS

I'll be teaching in the USA next year! 2013 SFO, NYC, BOS workshop details

My Photoshop Workflow DVD for photographers is now available, as well as a specific workflow DVD for the Leica M Monochrom!

100% Personalized photographic tuition: The Email School of Photography

Join our Flickr group!

Get your gear from Amazon - clicking here doesn't cost more, but it does give us a small referral fee. thanks!

Sign up to receive new posts by email

POPULAR RECENT POSTS

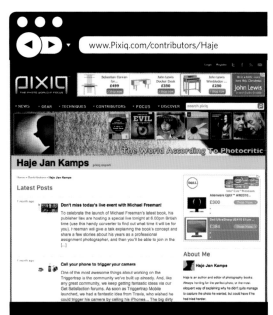

www.Pixiq.com/contributors/Haje

Haje Jan Kamps *pixiq expert*

Home » Contributors » Haje Jan Kamps

Latest Posts

1 month ago
Don't miss today's live event with Michael Freeman!
To celebrate the launch of Michael Freeman's latest book, his publisher Ilex are hosting a special live tonight at 6.00pm British time (use this handy converter to find out what time it will be for you). Freeman will give a talk explaining the book's concept and share a few stories about his years as a professional assignment photographer, and then you'll be able to join in the [...]

1 month ago
Call your phone to trigger your camera
One of the most awesome things about working on the Triggertrap is the community we've built up already. And, like any great community, we keep getting fantastic ideas via our Get Satisfaction forums. As soon as Triggertrap Mobile launched, we had a fantastic idea from Travis, who wished he could trigger his camera by calling his iPhones... The big dirty

About Me

Haje Jan Kamps

Haje is an author and editor of photography books. Always hunting for the perfect photo, or the most eloquent way of explaining why he didn't quite manage to capture the photo he wanted, but could have if he had tried harder.

"Every photographer aims to find a unique look to their images in order to create a signature look for their clients. I take inspiration from many sources— classical photojournalism, abstract art, motion picture and film—to deliver a unique look and style for my clients. Natural color and dynamic lighting create a strong positive emotion in the viewer, which in turn makes the subject of the photograph—your product or service—memorable."

- Ming Thien

Ming Thein is a working photographer based in Malaysia, whose blog features stunning, spontaneous street photography mixed in with professional studio shots shared from shoots for high-end clients. He balances his gear-review posts out with great images and thorough technical descriptions, all written from a very practical perspective.

But it's much more than just gear reviews—Ming shares a lot of his own techniques and insights, and is always ready to engage you in a conversation in the comment field. He couples this quality content with well placed promotions for his own services and workshops, making his blog part of his business.

"When he was 16 years old, Haje discovered that there weren't any decent websites about photography in Norwegian, and decided that he could do better. He started work on his first website, was proven wrong about the 'could do better' part, but was soon bought out by a bigger company who saw an opportunity. That website was digitalkamera.no—which today is the biggest digital photography site in Norway. Since then, Haje has taken hundreds of thousands of photos, written a few books, and has been running the highly acclaimed Photocritic photography blog. Currently, he is a full-time author and editor of photography books."

- Haje Jan Kamps

Haje's enthusiasm and personality shines through each and every post, and clearly indicates someone who has grown up in the blogosphere and feels as comfortable conversing there as anywhere else. The regularity of his posts is impressive, and he uses his blog to promote his many various projects—from his technological inventions (Google "triggertrap" for more) to his books (which were published because of the popularity of his blog). He is also very active on a variety of social media platforms, which helps readers keep in touch.

43

THESIS FIRST

Before you sit down at your computer with a cursor blinking in front of you and all that white space to fill, take a few moments to consider exactly what it is you want to blog about.

Each post has a thesis, and the best blog posts state that thesis clearly and quickly. If you realize you don't yet know what it is you want to say, it's best to put off writing until you have that crystal-clear thesis in mind. Plus, having your position firmly defined will make the writing much easier, faster, and better overall.

The thesis is a concept you probably learned about while composing your first essay in middle school. It's the main idea, a proposition, an angle, or a theory. Long before you start blogging, you'll want to be able to clearly express your thesis in twenty words or fewer; if it takes much more than that, your thesis isn't fully baked yet—or it might be too nuanced for most internet reading.

Let's illustrate with an example. Suppose you were walking around your town and happened upon a small protest. You captured a great, dynamic photo of a protester with your smartphone, and your local newspaper used the photo (with credit, of course) in a story about the event.

There are many theses that could come out of such an experience—a statement on intellectual property in the world of social media, the necessity of old-school journalists competing with gadget-happy over-sharers, etc. But if you begin with the main idea, "This thing happened to me, and it was pretty cool," it's not going to grab most readers' attention. Let's instead assume that the thesis would be our previous Chase Jarvis quotation: "The best camera is the one that's with you."

From that thesis, you know the point you're trying to convey: Even though you have much better equipment at your disposal, a simple consumer device, a smidgen of technique, and perfect timing were all you needed to capture an amazing photograph.

Crystallizing your blog into a thesis doesn't mean you need to abbreviate everything—you can still fully explore your ideas in long, well composed prose, but it will maintain focus throughout, and be more readable (and enjoyable) as a result.

www.TheSartorialist.com

THE SARTORIALIST

HOME SEARCH PRESS ARCHIVES BIOGRAPHY CONTACT BOOKS Search

Sunday, December 9, 2012

On the Street....Grand Palais, Paris

TIFFANY & CO.

CATEGORIES ARCHIVES

TheSartorialist.com
Scott Schuman

A runaway success, built from the simplest of ideas, The Sartorialist is the web's top fashion photography blog—but you won't find any elaborate studio setups or airbrushed supermodels in these posts. Instead, founder Scott Schuman seeks out innovative styles and unique trends in the most accessible place of all: the street. In his quest to create "a two-way dialogue about the world of fashion and its relationship to daily life," Schuman walks the streets of the world's metropolises with a camera in hand and a keen eye for chic outfits. His photos are a unique blend of street and fashion photography that skip over the mere presentation of expensive clothing and out-of-reach high culture to present an intimate view of the world as Scott sees it. This commitment to a personal philosophy has struck a resounding chord with fashionistas and photographers the world over, and demonstrates just how positively an audience will respond to a blog that presents the coherent vision of a capable photographer. Readers are as loyal to the Sartorialist as Scott is to his own sense of style.

Your best posts will derive from a succinct thesis.

45

THE INVERTED PYRAMID

Hit your readers with the important stuff right from the get-go.

A trick of the news-writing trade is to give the reader as much information as possible as quickly as possible. This technique, known as the Inverted Pyramid, puts all the vital details of each story at the very beginning, leaving less vital details for later on in the story, and nonessential elements at the end. The Inverted Pyramid isn't a hard and fast rule about how one must structure every story one writes, but it's a helpful guideline based on how people read and absorb information.

Especially in the digital age, your readers are constantly being offered all kinds of online content: videos, pictures, friends' mini-stories via social media, news articles, and tons and tons of blog posts. Starting your own post with the best, most important information—and a clear expression of your thesis— will allow readers to make a quick decision about whether or not they want to read (or share) your post. The more informative your post's title and first sentence are, the better your chances of getting that blog post read by more people.

Let's continue with our previous example. If you were writing that particular blog post, you could begin you blog post with the title, "What do we want? Citizen journalism! When do we want it? Now!" and continue with the sentence, "I was walking through town last week and was surprised to see a rag-tag group of young people holding a protest in front of one of the city's larger banks."

While this is a colorful way to start writing, it doesn't make it immediately obvious to the casual reader what the post is about, what the reader can expect to learn, or why anyone would want to read such a post. In the online world, this kind of writing will almost always disappear beneath a sea of text, pictures, and digital ephemera.

Instead, imagine the same story told with the title, "How a professional photographer can—and should—be a citizen journalist," and continue with the first sentence, "I've been doing photography professionally for nine years, but my most recent work (which appeared in this Sunday's Gazette), was the result of great timing and an iPhone 4S."

In that case, the reader immediately knows what the story or thesis is about—a photography pro who seized the moment and her smartphone to achieve a successful and newsworthy image. After that brief and accurate introduction, the blogger can continue with the story about the rag-tag protesters and the email from the newspaper editor, but "hooking" your readers out of the online sea requires great bait at the very start.

I've been doing photography professionally for nine years, but my most recent work (which appeared in this Sunday's Gazette), was the result of great timing and an iPhone 5.

↓

As you can see from the images, I wasn't able to zoom in from far away, but the fixed focal length (approximately 24mm-equivalent) of the iPhone 5 forced me to get in close, which added to the visceral quality of the images.

↓

They were processed simply using Instagram.

↓

I was able to email them to my editor in real-time.

↓

Citizen journalism is an important part of the Occupy Movement.

↓

So what do we want? Citizen Journalism! When do we want it? Now!

Top it off with a headline like "How an amateur photographer can, and should, be a citizen journalist."

47

WEB-SPECIFIC TIPS & TRICKS

You don't have to be a trailblazer—many tips & tricks exist to help you get your blog on its way.

Although it's helpful to start your blog posts with that journalist's trick in mind, the best part of the world of blogs is that it's full of voices—very real, diverse human voices with all kinds of vocabularies, accents, and quirks. Don't disguise the things that make your own voice unique. If you're the kind of person who says "y'all" and "dang," go ahead and write your blog posts the same way. (Be aware, however, that using certain kinds of adult language might alienate some readers; more on that later.)

As you're writing, if you mention a specific product, another photographer, or a post on another blog, be sure to create links to the relevant pages across the internet. Your CMS will have specific tools for creating links within the text of each post. When you add a link to your blog post, don't simply put the URL into your post. Instead, use your CMS or write HTML that uses the URL as well as relevant anchor text. For example, if I wanted to link to your blog post about how to shoot with infrared film, I would write, "Check out Diana's tutorial on shooting with infrared film," and the last four words of that sentence would be a link back to your blog post on the subject.

Linking out to other photographers' homepages or social media profiles, to other bloggers' posts, and to good information sources is good manners, and it's also a good way to get your own blog established as part of a larger network of online photographers and photo-blogs. As you create more content, others may start linking to you, as well, sending their own readers your way; so be generous with your links to other sites. Also, if you mention a blog post you've written before, be sure to link back to your own posts!

While linking back to others is good form, it does not excuse one of the cardinal sins of the internet: copying and pasting content without permission. It's

What goes around comes around—a key concept in establishing yourself within your particular blogging community. But even if you are directing readers to another blog, you should always ask permission before reposting someone else's content.

acceptable to quote a few words here and there—with a link back to the original source and proper attribution in the text of your own post—but never take more than a sentence or two, and never post a quotation without linking back. It's also highly inadvisable to download and re-post another photographer's images, even for illustration purposes and even with a link back.

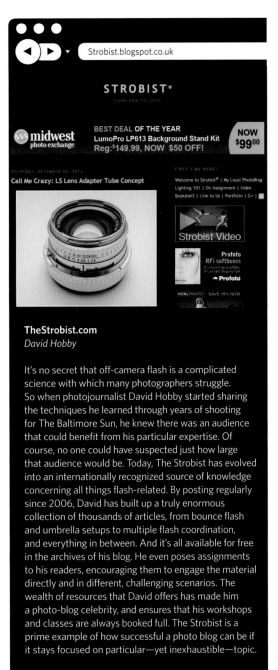

TheStrobist.com
David Hobby

It's no secret that off-camera flash is a complicated science with which many photographers struggle. So when photojournalist David Hobby started sharing the techniques he learned through years of shooting for The Baltimore Sun, he knew there was an audience that could benefit from his particular expertise. Of course, no one could have suspected just how large that audience would be. Today, The Strobist has evolved into an internationally recognized source of knowledge concerning all things flash-related. By posting regularly since 2006, David has built up a truly enormous collection of thousands of articles, from bounce flash and umbrella setups to multiple flash coordination, and everything in between. And it's all available for free in the archives of his blog. He even poses assignments to his readers, encouraging them to engage the material directly and in different, challenging scenarios. The wealth of resources that David offers has made him a photo-blog celebrity, and ensures that his workshops and classes are always booked full. The Strobist is a prime example of how successful a photo blog can be if it stays focused on particular—yet inexhaustible—topic.

Tags

✓ Portraiture

✓ Landscape

 Street

 Photojournalism

✓ Theory

 History

 Anecdote

✓ Best of

 Showcase

✓ Around the web

✓ Gear - Lenses

 Gear - Cameras

✓ Gear - Accessories

✓ Video

 Gear - Video

✓ Multimedia

 Citizen Journalism

✓ Review

✓ Technique

✓ Light & Lighting

✓ In Studio

✓ Copyright Law

✓ Travel

 Wedding

✓ iPhoneography

✓ Instagram

 Future Tech

You will build up your database of tags for each post as you grow your blog. Be sure to use them, but do so judiciously. Just checking every box defeats the purpose.

Another facet that separates your blog from any other kind of media is its built-in interactivity. Most CMSes have built-in commenting and even polling features wherein readers from around the world can leave you messages about your post (we'll dive deep into the niceties and not-so-niceties of commenting in a later chapter). While you are writing first and foremost for yourself and to achieve your own goals, keep in mind that your readers may have interesting and unexpected feedback for you. Feel free to solicit that feedback in the body of your post. For example, you can ask your readers if they have found solutions to a problem you're experiencing, or if they have any constructive criticism about a photograph you struggled to capture.

Also unique to blogs and other digital media is tagging. Think of tags as part of your blog post's catalog card. They help you identify the post and find it again if you ever need it. Tags also help your readers navigate through all your content, and they can play a big role in helping search engines understand what your blog is about. Your CMS will give you a little text entry field for entering tags; each post should have at least two or three tags of one to two words each. For example, for a post on using off-camera flash lighting, you could use "lighting," "flash," and "off-camera flash" as tags.

Your CMS may also give you the option of creating categories. These are broader than tags, but they can also help out a lot with reader navigation and search engines. For example, if you write more than a handful of posts about lighting equipment and techniques, you might want to create a "Lighting" category. Depending on your blog's focus, you might have a Portraiture category, a Client Work category, a Gear category, etc.

One of the great aspects of blogging is the instant feedback you'll have on your posts, especially once your audience starts to grow and comment frequently. Be open to their feedback, and incorporate suggestions into future posts as you see fit.

Finally, once you've got a couple dozen posts under your belt, your tags and categories will start to fill out a bit. If you're blogging about a particular topic, you can link important mentions of that topic back to the relevant tag or category page on your blog. So for one example, in the sentence, "The intern and I took some time this weekend to shoot an outdoor wedding on the outskirts of Pittsburgh," you could make the word "wedding" a link to your blog's "wedding" tag, which might be JasonKramer.com/tag/wedding. Again, this linking back will be a big help with both reader navigation and search engines.

Once you've taken your time, done all of the necessary homework, composed your post, inserted your links, and added all the necessary tags, don't hesitate—hit that big, glowing "Publish" button. Don't sit on the post or allow it to become overly precious or over-worked. Quickly proofread the text, preview the post for HTML errors, and publish it at once.

Here's why you can publish your work with such abandon. Your blog is unlike a newspaper article, book, or other media in this one most blessed aspect: You can go back and edit it as much as you like after the fact. Typos? No problem. Wrong image? Fixed. Anything you can do is undoable, and you can address any issues after the fact if need be. This isn't an excuse for sloppy blogging—proofreading remains important for preserving your professional reputation—but it does take a lot of pressure off you, the blogger, to get everything absolutely perfect the first time around.

As you develop a stronger readership, you will want to ensure that your posts are being published at an optimal time of day—probably between 10AM and 1PM in your time zone—to ensure that they get seen by as many readers as possible. Use your CMS's post-scheduling feature, usually available in the part of the CMS where you'd normally find the Publish button and options.

51

blog about your work

THE EXHIBIT

The image is at the center of any and all photography discussions, and showcasing your creativity will be an essential element of your blog.

As a photographer, one of the most natural types of posts to write is a simple show-and-tell about your work itself. Gallery posts may not need to contain a ton of text; rather, this is your moment to show off your best work to your online audience.

We'll call this type of post an exhibit. Much like a spot on an art gallery wall, this post is a quiet, well-lit space for you to display and explain a photograph— or a small collection of photographs, if you like.

This is a great opportunity to take advantage of your CMS's image-display features, such as lightboxing, sliders, or full-width image display, that truly let your photography shine.

Text for an exhibit can be minimal, with a simple explanation of the subject, location, technique, or any interesting notes about capturing that particular image. It is usually a good idea to include information about the type of equipment you used for that image and any settings you'd like to share with your audience, as well. If you leave this information out of your post, a commenter will usually request it.

In your image-editing software, resize the photograph to the largest size your CMS will display.

Depending on the theme you're using this could range between 500 pixels and a full-screen width option. Save the image as a high-quality JPEG, but keep an eye on the file size as previously discussed.

If you like, you can crop a section of the original size photo and display it to show details the reader might otherwise miss. Post this enlarged-details picture under the main image and its accompanying text. Along with the secondary picture, include some text that explains why you chose to highlight this detail and any techniques used to achieve the given effect.

If you'd like to use more than one image for the post, the exhibit should contain at most small handful of high-quality images, not more than five or seven, that are thematically linked but without redundancies (i.e., don't feature multiple portraits of the same person in the same setting or multiple snaps of the same landscape at the same time of day).

What you do not want to do in an exhibit post is a "photo dump" of dozens of pictures from a studio shoot, a portrait session, or an event. That's all good and fine for Flickr or Facebook, but on your blog, try to treat each post as a showcase opportunity. Pick

Try to treat each post as a showcase opportunity.

www.VisualScienceLab.blogspot.com

The Visual Science Lab / Kirk Tuck Welcome back to the Visual

Magazine ▾ | Pages ▾

Old Tech in Optimal Conditions = New Tech.
Shooting with old tech makes me feel confident that my vision is the driver, not the technology.

It's tempting to look outside yourself for your power but you'll feel like less of a photographic wimp if you don't depend on your gear for your sense of value.

In the end it's the image that matters, not how you got there.

Camera: Nasty old Kodak SLR/n. Lens: Ancient Nikon 70-200mm f4, 5-5.6.

©2012 and beyond. Kirk Tuck. Please do not re-post without full attribution. Please use the Amazon Links on the site to help me finance this site.

Picture Stories in Austin.
©2012 and beyond. Kirk Tuck. Please do not re-post without full attribution. Please use the Amazon Links on the site to help me finance this site.

What is it about the Olympus OM-D that makes it such a game changer?
The Olympus OM-D. Everyone's Camera of the Year in the 2012 Round-ups

A Bumper Crop for Traditionalists. Canon v. Nikon. Where's Sony?
Nikon's new D600. A few teething problems but a good entry into the market

Angles and Color.
These aren't the kind of images I make to generate money or business. I like them because they are quiet and fun for me to look at. It's easier for me to imagine them as art on the wall they portraits which in

a few gems from the session and display them with pride; you can always choose to link to a fuller set on Flickr or a similar, photo-specific site.

You CMS may allow you to feature a "gallery" of image thumbnails in your post. If such a feature isn't available, you can resize the images and place them in rows and columns, making sure that each one links to a full-size or larger version of the photograph.

Alternatively, if you prefer to have more control over how the images are displayed, you can build your own gallery-type meta-image in Photoshop. This kind of advanced post formatting will allow you to design the layout of one large image that will hold all the smaller images for that post, kind of like a photo album page. While your readers won't be able to click through and see the separate images, it will allow you to display the exact spacing, text, colors, and other design elements you desire.

This type of formatting is more common among design bloggers, fashion bloggers, craft/DIY bloggers, etc., but if the overall aesthetic is consistent with the rest of your blog, it can be a visually engaging and appealing device to use on occasion.

VisualScienceLab.blogspot.com
Kirk Tuck

Kirk Tuck is the kind of real-life, down-to-earth photographer with whom you'd feel comfortable going on a casual photo walk. In blogging about the day-to-day operations of his successful photo studio, he writes in a pragmatic language that pulls back the curtain and invites readers to have a look around his business with a familiar and approachable tone. His no-nonsense personality shines through in every post, never gets bogged down in technical evaluations of gear, and always offers up loads of straightforward business advice, mixed with dependable techniques that are sure to consistently satisfy clients. As a result, The Visual Science Lab is as inspirational as it is informative—so much so that you probably don't even realize it's also a great way for Kirk to sell both his photographic services and his books. It's an old-fashioned, "what-goes-around-comes-around" approach to building up your photo business: Start by sharing your expertise for free, in order to cultivate an audience and establish a positive online reputation; then let your readers choose to hire you or buy your book on their own accord.

blog about your methods

THE TUTORIAL

Not every image needs a behind-the-scenes, do-it-yourself explanation. But if you ever have a lightbulb moment during your creative process as a photographer, especially if you had to struggle a bit before the lightbulb "lit up," it's probably worth sharing with the internet, as well.

These posts are so perennially popular because photographers and designers of all stripes are constantly combing the web and search engines looking for ways to improve their skills and create better-quality work. Lighting tutorials, gear tutorials, image-editing tutorials and the like all rank high in the minds of your readers and the search engines they use to find your blog.

Also, tutorial posts, if they are well-written and on timely or interesting topics, are perfect "link bait." Link bait is a term for any post you write that just begs to be mentioned and linked back to from other blogs and websites. Well-written link bait with valuable information can help you grow your base of readers and increase your standing in the large community of online photographers, as well.

For some tutorials, a step-by-step text guide with explanatory images for each step is ideal. For other types of tutorials, you may want or need to make a video to get the lesson across. If the action is taking place on your computer screen (for example, if you're doing a tutorial on image compositing), you'll want to use a high-quality microphone and screen-capture software—neither of which are great investments unless you plan on doing a lot of screencasting tutorials. Otherwise, you can use simple movie-making software such as iMovie or free or inexpensive versions of Sony Vegas (for Windows users) to quickly and efficiently edit together still images, video, and text.

If your tutorial post gains enough popularity (and is linked to enough from other sites) it can become a standard reference for a particular technique, and rise to the top of search-engine results, which will then in turn pull up the ranking of the rest of your blog.

*If you have an area
of expertise, share
your knowledge!*

Here are a few tips and some examples to get you started:

▶ Be specific, but explain any jargon or technical terms—not every reader is a professional photographer!

▶ Be extremely to-the-point in your post's title, for example, "How to light a person in the midday sun" or "Five tips for lens flare photos."

▶ Use a how-to tag, or if you write a lot of tutorial content, create a how-to category or post series.

▶ Stick to your specialties. You can grow your audience by becoming known for your expertise in a few specific categories, such as landscapes, image editing, or event photography.

▶ If you're not a great expert, you can still write a tutorial post. Just be sure to note that your how-to is a beginner's guide or notes on how to get started with a particular technique (e.g., "How I lost my HDR virginity" or "Panoramic photography for first-timers").

▶ Show great example photography, including side-by-side before/after images if available.

▶ Err on the side of over-explaining. Go thoroughly and slowly through all your steps.

▶ If you're using specific equipment or software, be sure to mention any important details such as device models, operating systems, version numbers, etc.

▶ If your tutorial calls for specific equipment/software, be sure to tell your readers how and/or where they can obtain the exact thing you used. If an approximation will do, be sure to note that in your post.

▶ If you're an expert in a specific technique or with a specific device, consider writing a "beginner's guide"—the web is full of beginners who would benefit from your wisdom!

▶ The web is also full of folks who are short on resources but long on time and creativity, so your DIY posts on clever "hacks" or workarounds are also sure to be long-term successes.

▶ Nothing makes for "click bait"—those impossible-to-not-read posts—as lists. A numbered list of great tips will bring readers back over and over again for months and even years. For example, you could create a post of eight tips for smartphone photography or five ways to shoot better nighttime photos.

55

blog about your subjects

STORYTELLING

Not every photo blogger is a natural storyteller. After all, our pictures are supposed to be worth a thousand words and usually tell stories themselves.

However, every now and then, an image has a certain backstory that's too good not to share. Whether you had to overcome huge obstacles to get the perfect shot or your human subject's story made the image even more poignant, there can be times when you get to be the raconteur as well as the shutterbug.

Narrative can bring a beautiful element of personality and creativity to your blog. If you're not a natural storyteller, you can keep these kinds of posts brief. And not every photo blog needs to contain narrative posts. But the best ones often do, and they do so in a way that is unique to that photo blogger's style and voice.

Narrative posts are an opportunity for bloggers to get to know your personality, so preserve your distinct writing style and try to come across as a genuine, real person on the other side of the blog. These will also be excellent posts in which to engage your readership in the comments section.

Narrative can bring a beautiful element of personality and creativity to your blog.

Storytelling posts can break away from the Inverted Pyramid structure we discussed earlier. While it's still best to let your readers know early on what your post is about, most readers will accept that a good story has a beginning, a middle, and an end—and the patient readers will (hopefully) realize that the ending is worth the wait.

However, because the internet is such a public place, I caution you to obtain very specific permission if you plan on blogging about stories that are not yours alone. If you want to share a personal anecdote about a human subject or even your subject's name (whether a full name or a first name), it's best to give that person advance warning with a very accurate description of what you plan to share, then wait for that person to respond affirmatively.

And if you're writing a story about yourself, well, just remember, the internet's memory is long. Even if you delete your post, it's guaranteed to be cached or archived on some server somewhere. So carefully consider how personal you want your personal stories to be (we'll talk much more about personal blogging in just a bit).

In narrative posts, your photographs can act almost as illustrations. You may choose to feature just one big, beautiful image, like you would for an exhibit post. Or if the story you're telling has multiple parts that relate to photos you've captured, you can feel free to insert several images as you weave your tale.

Here are a few tips for telling great stories on your blog:

▶ Start by thinking about what makes the story different or special, then think about how the story applies to the tone or subject of your blog. Keep both those elements in focus while you write.

▶ Be sure to use a "hook" in your headline or opening sentence; remind the readers why this story is so unique, why this one blog post is a must-read for them.

▶ Set the scene very specifically, using the five W's (who, what, when, where, why) as a starting point.

▶ Use direct quotations if applicable, and preserve any quirks in the dialog of others.

▶ More than at any other time, use your own voice, and let your personality shine through. Write in a conversational tone, like you're talking to a friend.

▶ Give lots and lots of detail, and try to "show" instead of "tell." For example, instead of writing, "It was hard to shoot in such windy conditions," write something like, "Every time I was about to press the shutter, the wind would shove another piece of debris in front of my lens."

▶ Express emotions—yours, your subjects'—honestly and directly, again showing rather than telling.

▶ Don't dwell on overly long descriptions, though. Use lots of verbs to move the story forward.

▶ The classics of storytelling—setting, conflict, and resolution—still apply in a blog post, even if the conflict is internal or subtle.

▶ If you're telling a story with more than one image and more than one location or subject, make it very clear how your images are linked through the theme of your story.

▶ End your story well. Don't let the narrative trail off, and don't try too hard to make a corny moral if there isn't one.

blog about yourself

PERSONAL BLOGGING

Sometimes the story of what's going on behind the camera is even more interesting.

One of the most unique and endearing parts of the world of blogs is that it's personal—highly personal at times. The best bloggers are known for sharing bits of themselves and revealing their humanity and personality through their posts.

Personal blogging has its place in a photo blog, too. As you develop your voice and material, your regular readers will want to know more about who you are and what makes you tick. The occasional and well thought-out personal blog post will create a special bond between you and your readers.

Your personal blog posts will usually be anchored with a leading photograph or a series of images that relate to the main point you're trying to convey. In some ways, a personal blog post can be quite similar to a narrative post. The key difference is that while it might tell a story, its real purpose is to reveal something about you to your readers. Hence, a personal blog post's tone will be that of a heart-to-heart chat between you and an intimate friend.

In order to reveal yourself to your audience, you must first know yourself. What makes you unique? More to the point, what parts of your personality are compatible with the larger goals of your blog? When you want to create a personal blog post, hone in on those points, and craft your sharing around them. Just because a post is personal in nature doesn't mean it should lose focus or detract from the rest of your content.

For example, you could tell your readers about why you took up photography in the first place, or about your journey to improve yourself as a photographer. You could share with your readers a photograph of yours that has a profound emotional impact on you or that tells a story about a turning point in your life. Personal posts are where you get to be your truest self, and where your readers get a satisfying answer to the question, "Who is this blogger, anyway?"

Just remember, for better or for worse, the internet is all about creating a personal brand. Particularly when you sit down to write a personal blog post, be aware of the brand you're building. You don't have to incessantly harp on your business, plug your products, or use your catchphrases—in fact, it's much better if you don't! But know that every post is one small piece of a larger puzzle, and readers are putting those pieces together each time they visit your blog. Make sure the picture they get is consistent; make sure all the puzzle pieces fit together.

If you're blogging for business reasons, personal blogging can be an awesome way to talk about the kind of business you're building and to define your character for prospective clients. If your primary goal in blogging is to build your business, just be especially careful to only share the kinds of anecdotes that you would be comfortable sharing in any other professional situation—for example, at a networking event or at a client's social gathering.

The internet is all about creating a personal brand.

As I've mentioned briefly already, be very careful about how much of yourself you expose to the Internet. The word "oversharing" can mean different things to different people. There are photographers and bloggers who love wearing their hearts on their sleeves and who thrive on absolute and brutal authenticity, even on the public web. For most of us, however, living life online requires a bit of balance. We need to give our readers enough personality to let them know we are human and to keep them interested and engaged, but we also need to protect our privacy and the privacy of our friends and families. From interpersonal dramas to residential locations, have a very clear understanding of your own blogging boundaries between what's shareable and what's not.

Finally, we artistic types can also tend at times toward narcissism or self-deprecation. While posting the occasional personally oriented musing is practically de rigeur for every blogger, keep in mind that your blog is a blog about photography, not about you. Maintain a good balance of humility and healthy pride in your work when you refer to yourself, your travels, your lifestyle, and so on.

TheOnlinePhotographer.TypePad.com

TheOnlinePhotographer.com
Mike Johnston

"TOP was founded so photographers from around the world would have a place where they are assured of finding new content every day. We publish about 360 days a year and average 2.5 posts per day. We cover anything and everything of interest to practicing photographers. Our focus is more on art and accomplishment and less on technique and equipment than many of the largest sites, but we do cover gear and technical issues as well as artists, photojournalism, shows, and people."

- Mike Johnston

The Online Photographer (aka TOP) has a venerable reputation in the photo blogosphere. Editor-in-Chief Mike Johnston has been blogging since the early days of the medium, and before that worked at the helm of two major photography magazines. Having seen it all before, he brings a sort of tempered wisdom to the online photo community. He covers it all—from gear reviews to gallery openings—but it's his sage and artfully composed insights into aesthetics that distinguish him (and his guest bloggers).

blog regularly & consistently

The need for consistent content can be both intimidating and inspirational—and with steady planning it will be much more of the latter.

The very best thing you can do to grow your blog's readership is to post consistently. You don't have to post every day; in fact, posting more than once a day is probably overload. But make a point of posting three to five times a week.

Sometimes, you might not have time to post for a week or more, especially if you're traveling or shooting in a location where you don't have reliable internet access. In those cases, try to set aside a couple hours and schedule posts for while you're away or busy. Scheduled posts could be brief updates or single-photo exhibits of your work, present or past. But a steady stream of blog posts will keep your readers coming back consistently. The moment you stop posting a few times a week, your readers will drop off and forget to come back until you give them a reason to again.

In future chapters, we'll go into detail on how to get material for consistent, regular blogging, even when you're busy or worse, uninspired. Photo walks, personal challenges, posts from other bloggers, and even comments from your own community will give you ample fodder for posts. But as long as you are diligent and just a bit creative, you will be able to maintain your audience's interest.

The straightforward task of planning out a month of posts in advance can save you a lot of stress and headaches—and can even help spark your creativity. Consider parts of it flexible, but use it to pace yourself, and set regular goals to achieve so that you don't suddenly find yourself overwhelmed.

august

29	30	31	1	2	3	4
	Vivian Maier Gallery post			Vivian Maier Book Review		
5 **FLASH**	6 **WEEK!** bounce flash tutorial	7 SB-900	8 review	9	10 'best of strobist articles	11
12	13 Vacation photo gallery from Thailand	14	15	16	17 PhotoPlus Show Floor Reports	18
19	20 Nude Photography Overview	21	22 GUEST POST Frank Derouen	23	24	25
26 NEW CANON	27 DSLR ANNOUNCEMENT sometime this week-contact Canon for NDA	28	29	30 New Exhibit Announcement @ George Eastman House	31	1

TEN TIPS FOR SUCCESSFUL BLOG CONTENT

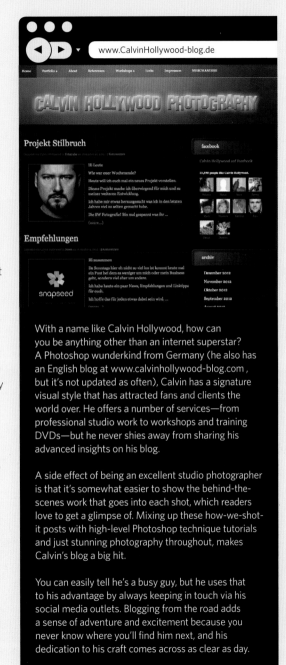

1. Have a hook. An eye-catching photo, an attention-grabbing title, and a powerful first sentence are your best friends.

2. Be yourself. Write like you talk, and write about what is real and important to you.

3. Be bold. Readers love it when you take risks.

4. Give, give, and give again. Be generous with links, information, tutorials, and your personality.

5. Encourage interaction. Ask for and respond to comments from your readers.

6. Keep an eye on design. Emphasize your photography through great layouts.

7. Know how to tell a good story.

8. Be personal, but respect privacy.

9. You'll never go wrong by avoiding negativity and drama. Never call out another person or business.

10. If your photography or language are not safe for children or workplaces, let your readers know. Sometimes, your CMS will let them know in the form of a splash screen asking for acknowledgment of adult content ahead.

With a name like Calvin Hollywood, how can you be anything other than an internet superstar? A Photoshop wunderkind from Germany (he also has an English blog at www.calvinhollywood-blog.com , but it's not updated as often), Calvin has a signature visual style that has attracted fans and clients the world over. He offers a number of services—from professional studio work to workshops and training DVDs—but he never shies away from sharing his advanced insights on his blog.

A side effect of being an excellent studio photographer is that it's somewhat easier to show the behind-the-scenes work that goes into each shot, which readers love to get a glimpse of. Mixing up these how-we-shot-it posts with high-level Photoshop technique tutorials and just stunning photography throughout, makes Calvin's blog a big hit.

You can easily tell he's a busy guy, but he uses that to his advantage by always keeping in touch via his social media outlets. Blogging from the road adds a sense of adventure and excitement because you never know where you'll find him next, and his dedication to his craft comes across as clear as day.

4 *community*

One of the great parts of being a blogger is the fact that you get to interact with your audience. We touched on this just a little bit in the previous chapter on content. But when you've done your part by creating great content, readers get to do *their* part by responding to it, sharing it, and getting more involved with you, your blog, and each other.

Building a community is an exciting and sometimes exhausting endeavor, but it brings you close to your audience and creates real connections between you and your readers. And when those connections start to form, you'll see some interesting "network effects" on your blog.

A thriving network can start to have a gravity-like effect on the surrounding areas of the internet. The stronger your community becomes, the more readers will get pulled into it. One regular reader will share a link in a tweet, another will email his friend about an insightful post you wrote. Little by little, your readership will grow; as you make connections on a personal level, your network will grow. And as your network grows, so does your personal brand, your business, and your overall ranking in the world of photo blogging.

creating a community in comments

Don't be shy—if your readers were interested enough to leave a comment, you should meet them halfway and start a dialog whenever possible.

The first, easiest, and most obvious way to start building a community is by reading and responding to the comments on your blog.

Note, I did not say by obsessively checking and pondering the deeper meaning of the comments on your blog.

This can be hinky territory for even the most self-assured photo bloggers. Your snaps and scribbles will acquire a diverse crowd of readers, and not all of them will be supportive, pleasant, or sane. That's the gamble you take when you work in the public eye. Prepare yourself for some positivity, some neutrality, some negativity, and a healthy serving of spam, and try not to take it all too seriously.

If you're particularly concerned about angry, unpleasant, or profanity-laced comments, your CMS will likely give you an option for pre-screening comments before they are publicly published on your blog. If you choose to moderate all your comments this way, try to check for new comments at least once a day, more frequently if you get more than a handful of comments.

With that caveat in mind, know that the comments section on any post can be a lively salon for fascinating conversations between peers. Beginners can ask you questions; you can respond with specific tips. Old pros can offer you suggestions for new techniques to try. Avid fans can give you digital applause, and thoughtful connoisseurs can give you constructive critiques.

You don't have to respond to every comment you get. In fact, many of your commenters' thoughts may be along two well-worn lines: "That's great!" and "Me too!" While these kinds of responses can certainly enliven and flesh out your comments section, they don't really add much substance to the conversation you started when you published your blog post, and they don't necessarily require a response from you. If you'd like to respond, you may absolutely do so, but be advised that the blogger who responds to every comment creates a cluttered conversation stream and cultivates an overly eager image.

Rather, it might be best (especially when you start getting more than one or two comments on a given post) to chime into the comments only when you have a specific thought to add, a question to address, or a point to clarify. Think of yourself as the host or hostess at a reception. Your job is to welcome people in, set the tone for the event (both of which you've already done in your blog post), and then facilitate a natural and pleasant conversational flow. Too much chatter on your part is as destructive to said flow as stone silence.

When you chime into a conversation in the comments section underneath a post, you can reply to a group or to a specific commenter. Just avoid confusion by being specific about whom you're addressing, and be as clear as possible with whatever point you're trying to make or question you're trying to answer.

In general, your readers will be delighted to know that you're not only an engaging writer and terrific photographer but also an active participant with your fan and friends online. You'll probably build ongoing online relationships with at least a few folks who return frequently to read and comment; it's the very beginning of a community and can end up being one of the strongest parts of your blog if you choose to make it so.

When responding to comments from others, be as personable as you would if you were speaking to them in real life. After all, when you take away all the code and pixels, we're all flesh and blood, very real and distinct personalities that are quite connected through the internet. Even though we may be physically remote, we should strive to be as polite and respectful as if we were sitting next to one another in a public place.

Practicing such courtesy is easy when you're answering a simple question or responding to a positive remark from a fan or friend. However, when a reader has a critical comment, it can be difficult to rein yourself in. The web gives us all a powerful feeling of invulnerability, and too often we take this feeling as license to insult and shame others whom we perceive as insulting us.

The folks behind the Focus Numerique realized in 2005 that there was a particular dearth of French-language photography blogs, and seized a golden opportunity. It's grown by leaps and bounds over the years, and now is one of the biggest French photography websites online. It is largely gear-focused, offering all the latest news from the camera manufacturers, lens tests, image-quality assessments and so on, but also has built up a valuable database of instructional posts that persist in popularity due to their regular updates. Some of these are high-end shooting methods, some are post-production techniques, some are simply stories from the road by professional photographers. The variety and quality of imagery makes it very easy to get lost browsing through all the posts.

Besides the posts, there's also a regular photo competition, to entice reader participation. And there are a number of extremely active forums where the wider online community can debate the merits of the latest sensor designs, give advice for specific shooting scenarios, offer critiques of images, and more. Forums like these can sometimes grow so massive they become the tail that wags the dog.

DEALING WITH NEGATIVE COMMENTS

No matter how cheerful your posts are, you will invariably have to deal with some naysayers and nasties at some point.

Getting critical comments—be they constructive or otherwise—is absolutely unavoidable for any blogger. In fact, fear of such comments has held many a creative soul back from blogging. But you shouldn't let your apprehensions about this facet of online life intimidate you or detract your enthusiasm.

In fact, your policy on and reactions to negative comments can be a huge factor in establishing the ethos of your blog's community. How you respond to these kinds of comments will set you apart and define your character—and, if you're blogging as a business owner, will send strong signals to your potential commenters.

Different bloggers have different approaches. The thoughtful will carefully engage detractors in an intelligent and reasonable debate. The thick-skinned will poke fun at meanies. The Pollyannas of the internet will post a thorough section on their expectations of positive commenting and will delete anything with a hint of snideness or profanity.

But every seasoned blogger will have developed their own techniques for dealing with negative comments. Here are a few helpful tips and coping mechanisms for the bad/ugly spectrum of comments, from the ugliest insults to well-meant critiques:

Don't feed the trolls! This is Rule One of online communication. It simply means that while you will encounter "trolls," i.e., web-dwellers who exist online for the purpose of inflicting emotional pain on others, you are under no circumstances to "feed" them, i.e., show any sign that you notice or are affected in any way by their antics. If you get a "trollish" comment, delete it, do not respond to it, and move forward immediately without paying any further mind.

Take the high road. If someone leaves a nasty comment or one that's just critical of your work, you can always come out on top by being unflappably gracious. A simple, "I'm sorry you feel that way. Have a great day!" can quickly and successfully close the matter, allowing you to save face, still remain in control of the situation, and not be dragged into a flame war (a heated back-and-forth that sucks everyone involved into a maelstrom of negativity and hyperbole).

Sometimes, you don't have to respond with a correction or rebuke to an obviously incorrect negative commenter. Your other readers will come to your rescue—a good sign of a healthy community.

Delete, delete, delete. You're in charge here; this is your playground. You are in no way obliged to publish every comment you get, and you can delete anything that doesn't fit in with the vibe you're trying to cultivate. Free speech certainly has its place, but your blog isn't

It goes without saying that people act differently online than they do in real life. It takes a cool, collected head to rise above the noise sometimes—but patience and an even temper almost always pay off.

a public or government-owned property. If detractors want to speak freely, they can darn well set up blogs of their own.

Don't fear the banhammer. The banhammer is your privilege as a blog owner; in most CMSes, you can permanently ban any commenter who you feel is dragging down the tone of the conversation with verbal abuse, threats, or profanity (if that's not okay on your blog).

Take a deep breath. If you get a particularly vitriolic comment that just sets your teeth on edge, walk away from your computer (or shut down your smartphone) and go blow off some steam before responding (or not responding, or just deleting the comment altogether).

Some low-blow comments will go straight for your emotional jugular. In those moments, you might need a mantra; I have a few of my own! "These people don't pay my bills" is a perspective-saving personal favorite that reminds me why I blog and reinforces the fact that a bad comment has no real-world impact on me.

Negative isn't always nasty. Some folks will leave comments that they didn't like your work or they didn't understand your story or they hate the lens you're using, and so on. Don't let it get to you emotionally, and assume that the commenter meant well. If you start by giving them the benefit of the doubt, you can decide for yourself whether the criticism does, in fact, have any merit; but if it was made without malice, there's no need to get upset.

67

Laugh! Sometimes, an overly negative commenter is so off-base that their words go from offensive to just plain bizarre, outlandish, and ludicrous. Feel free to shake your head and chuckle. One seasoned pro in the blogosphere tells me he likes to reply to these commenters with three simple words: "You fascinate me." It's a little wink-wink that lets other commenters know you're in on the joke and don't take the negativity to heart.

Just remember: Your commenters, positive and negative alike, don't really know you. Any comments they leave are more a reflection on them than on you. Dark people leave dark comments, and we have to pity them for not having better things to do with their lives.

Finally, there might sometimes be posts that stir up strong reactions or controversies in the community. Likewise, if you do any personal blogging, you might also find yourself delving into some very tender territory. In most blogging software, you can turn comments on and off for an individual post, and on my own blogs, I will very often flip the switch into no-comment mode if I feel that I've said all I have to say and I don't particularly need or want feedback from others.

This might strike some of your readers as a high-handed way of avoiding criticism, but look at all the facts: You took the time and effort to set up a blog, do all your photography, and craft a well-thought-out blog post on a perhaps sensitive subject. It's your work, and no one is entitled to any part of it. If you don't feel like subjecting yourself to commentary—positive or negative—you can simply close the comments section.

When I do this on my own blog, I run a brief disclaimer at the bottom of the post, where the comments section would normally be found:

"Comments are closed for this post. You are encouraged to disagree, debate, or expand the conversation on your own blog; you will be linked to via trackbacks and pingbacks."

It's a polite but firm way of telling your readers that while you appreciate them, this particular post is a one-way talk or speech or demonstration rather than a roundtable discussion.

OK, it doesn't exactly require riot gear to moderate your comment threads, but thick skin and firm standards certainly help. You're basically there to keep the peace, and steer the discussion away from the flames and toward productive topics.

A FOOTNOTE ON SPAM

They can be totally bizarre or eerily almost-human—spam comes in all shapes and sizes.

Spam is more than just a debatably delicious canned meat, and it's more than just the junk that clutters your email inbox. As a new blogger, you'll get to experience the joys of comment spam, as well. *Hooray!*

The good news is, most CMS makers are well aware that comment spam is a big problem and have whole teams of engineers devoted to rooting out spam comments. Make sure that you're using whatever plugins your CMS recommends for spam-fighting (this may be automated).

To identify spam, check the name, email address, and website link provided by the commenter. If they seem like outlandish strings of unrelated letters and gobbledygook, chances are good that they're the work of a spambot.

Also, do a double-take at the content of the comment. Is it vaguely positive but totally generic? Could it be left on a blog post about any other topic? Does the language seem disjointed and riddled with poor spelling and grammar? Again, these are tip-offs that the comment is spam.

Don't just delete the comment, though. Be sure to mark it as spam so your CMS's spam-fighting software knows to be on the lookout for similar comments featuring the same text, from the same IP address, etc. And whatever you do, don't click on any links that look suspicious—that includes shortened URLs that disguise the actual website you're visiting.

Below is a real example of a spam comment from my own blog. With time you'll learn to spot these from a mile away.

Name: **Derronx Bernadettec**
URL: **plus.google.com/TotallyLegit789**
Email: **TotallyLegit789@gmail.com**

"I do believe all the ideas you have introduced in your post. They're very convincing and can definitely work. Nonetheless, the posts are too quick for newbies. May you please lengthen them a little from next time? Thanks very much for the post."

✔Improbable name? ✔Suspicious email address?
✔A link to a G+ account with one link that just leads to a marketing website?

Ladies and gents,
we have ourselves a spambot!

69

blogger networking

IT MIGHT BE A SMALLER WORLD THAN YOU THINK

What seems tough at first will become thrilling as soon as you receive your first reply from a blogger you've been enthusiastically following on your own.

Once you have built up your own stream of interesting, insightful posts with lively comments sections, it's time to start networking to establish yourself within your particular niche of photo bloggers. This is important for a few reasons:

- It builds your reputation and lends to your credibility when you are acknowledged by well established photo bloggers.

- It builds links back to your blog, which help you out with the search engines.

- It can help to send traffic (i.e., new readers and prospective clients) back to your blog.

- It gives you a sense of belonging to a community; you're not just writing into a void.

- It's actually quite fun!

KNOW YOUR NETWORK

As a new blogger coming into an already crowded internet, networking is a bit like going to a huge party where you don't really know anyone yet. You might recognize a few faces, but no one recognizes you. It's hard to know how or where to start making conversation, and you're not quite certain how others will react to you.

The first step to building your network is reading— a lot of reading. This is the lurking phase, when you'll observe other blogs' content as well as their community interactions, taking notes on how to make friends and influence bloggers.

You'll want to become a regular reader of blogs that are somewhat similar to your own. For example, if you're a non-professional photographer who also blogs about family and cooking, you could take a cue from ThePioneerWoman.com, a blog chock-full of stunning photographs about family life and culinary arts as they unfold on a working ranch. Or, if photo lessons mixed with inspirational messaging and positive thinking is your bag, perhaps try reading Chookoolonks.com, which will bring you a steady stream of images showing inner beauty and stories about human diversity, love, and friendship. All across the web, you'll find photographers like you—mom photogs, LGBT photogs, travel-junkie photogs, foodie photogs, you name it—who have set up blogs to show the world what their lives and photos are like. You might be surprised at how much you have in common with these more established photo bloggers.

Also, it's a good idea to start reading photo blogs that match up with your own on a few other levels, not just content. If your location has any impact on your blog at all, check out other photo bloggers in your city or general geographical area. And if you're blogging to support your business, don't think of similar bloggers as competition; it's more productive to think of them as contacts and potential referrals.

It might seem intimidating, but remember that you aren't exactly starting from scratch —you already have a common set of interests with your fellow photo bloggers, and they'll likely be just as excited to hear from you as you are to talk to them.

While it's a great idea to read collaborative or professional blogs, such as Ben Trovato for fashion photography or the Bon Appetit blog for food photography, it's harder to network there. Going back to the party analogy, networking on these blogs would be like going to a trendy nightclub and trying to make time with the hottest bartender: Everyone else is competing for a small group's attention, and unless you've got some major cachet, it ain't gonna happen. At least for now, it's best to read the big, professional photo blogs for instruction and inspiration, and leave your networking for single-author, non-professional photo blogs.

Finding blogs to read is one of the simpler tasks on your agenda. Use a search engine, and plug in the terms most relevant to your niche, e.g., "music photography blogger" or "photojournalism blog." You can also check the blogrolls for the blogs you might already read, and try asking around among your friends on Facebook, Twitter, or other social networks. This book also contains many great examples of successful photo blogs, all of which are strongly recommended; you can find a list of them on page 160.

Don't limit your internet stalking to just blog-reading, either. Find your favorite bloggers on Twitter, Facebook, Google+, Pinterest, Instagram, and Flickr, and follow them!

71

SAY HELLO

More than just "hello," but less than your life story. Make your first contact appear genuine.

Name: **Frank Derouen**
URL: www.stilnovistophoto.com
Email: EnjoyPhotos717@gmail.com

"That certainly strikes home with me. It took forever to build up the nerve to immerse myself in the action. Reminds me of Robert Capa's advice: 'If your picture isn't good enough, you're not close enough.'"

Once you've got a good roster of blogs (and an RSS reader, Twitter feed, or other such mechanism to make sure you stay current and see new posts as they are published) and get into a rhythm of reading them regularly, make mental notes on how the photo bloggers themselves involve their own communities. Are they responsive in comments? Do they write posts containing questions for or references to their readers?

One good way to start networking is simply to leave a comment, especially if you have something more interesting to add than "Great post," or "I'm new here, but I like your blog." Again, going to the party metaphor, you wouldn't walk up to another person at the party and start a conversation with, "Hi! I'm new here. You look nice."

Your first comment should be something interesting—a question, a (brief) similar story you could share—and should not be threatening or critical. If (and only if) you've written a blog post on the same topic with a high degree of similarity to this blogger's post, you might note so with a link back to that specific post. In general, though, it's bad form to pepper your comments with links back to yourself; that kind of aggressive bid for attention will simply aggravate your fellow bloggers' nerves and just might get you marked as spam.

The best part about asking a question as your first comment is that it gives the other blogger a great reason to respond to you. This kind of dialog will eventually lead to her remembering your name and perhaps even clicking on your URL and discovering fantastic new photo blog. Make your questions specific, and always thank the blogger if you get a response.

When you go to someone else's blog, you'll likely need to login to a commenting system. If the other blogger users the same web-based CMS you use, your profile might carry over into his or her commenting system. If this isn't the case, you can almost always use a social media profile as a login. If you connect through Facebook or Twitter, you'll have the added benefit of bringing your profile picture along with you—always a plus when you're trying to make a human-to-human connection! Just make sure the Facebook/Twitter/Google profile is the profile that's linked to your photo blog, and you're good to go.

You can also get the same results by commenting directly to the photo blogger via social media. Just be aware that the more "internet popular" a photo blogger is, the less likely your comment or tweet is to make a lasting impression.

MAKE AN INTRODUCTION

Don't expect links to your blog without giving a few out first!

When you've made the rounds as a reader and commenter, one surefire way into any photo blogger's heart is a link. Also known around the blogosphere as "link love," a simple text link from your blog to someone else's blog is like a warm plate of cookies offered to a new neighbor: No one doesn't like it!

To show another blogger some link love, simply create a new post (or, if the topics are sufficiently intertwined, use an existing post), and tell your readers they should go over to so-and-so's blog for a great post on techniques for shooting macros, making the words "techniques for shooting macros" a hyperlink back to old so-and-so's specific blog post. In all likelihood, your link will pop up as a trackback on so-and-so's blog post, and she will see your post and be quite flattered.

When you link back to someone else's post, it's okay to grab a sentence or two as a direct quotation, but never, ever use someone else's photograph on your blog unless you've been given explicit permission to do so, and then, include an obvious attribution to the photographer. Content-stealing is a bona fide problem all around the web, and nowhere more than in the circles of photo bloggers. Stealing content, even with the best of intentions, will get you quickly branded as a digital thief at worst or a hopeless noob with no understanding of intellectual property at best.

Link love is distinct from your blogroll, which is also a great way to acknowledge your network of similar bloggers. The blogroll is a distinct menu or sidebar on every page throughout your blog that acts as a recommendation engine for your readers, pointing them to the blogs that you consider on-topic and high-quality reading. The blogroll can be controlled through your CMS via a blogroll widget, and you can and should include any blogs you read on a regular basis that you would particularly recommend to your readers or with which you'd most like to align yourself.

And of course, share the posts you love with your own readers and fans via social networks. You may want to set up distinct social profiles for your photo blogger persona (more on that later) so as to avoid bombarding your non-photog buddies with links and chatter about photography.

A more advanced form of link love is the blog carnival. This is a specific post type that collects a selection of links often with a theme and on a regular, periodic basis. The links will direct your readers to blog posts from others. In most cases, a carnival is a regular feature with rotating hosting duties. In other words, the hypothetical monthly Carnival of Lights will round up the best photo-blog posts on lighting; this month, you'll write the post and curate the links, and next week, Bob of Bob's Amazing Photo blog will "host" the carnival, curate the links, and publish the post. Carnivals can be set up by any informal network of topical bloggers; you might also start writing a carnival for your topic of choice, then pass the baton to another blogger as you start to build your network.

73

NETWORKING UP, NETWORKING ACROSS

Ambition is a valuable asset—but so is patience and respect. It's best to play the long game and gradually work your way up the hierarchy.

Depending on your blog's goals, you might start out with the ambition of becoming the most popular photo blogger the internet has ever seen; but wherever you start, you'll be at the bottom or close to it. Whether you're building your business or simply building your audience, it's natural to want to "network up"—that is, to cultivate online friendships with more popular, important bloggers and eventually convey the impression that you are part of the same sphere.

When networking vertically, make a mental map of the photo-blog ecosystem, and know where you fall in the food chain. Get to know folks at your own level—people with parity to you in skill sets, online followings, and general temperament. Be friendly, reference each other's work online, and point your readers in these bloggers' direction every now and then.

Take the time to get familiar with folks at a more advanced level, as well—longtime photo bloggers whose work you admire and whose online followings far eclipse your own. It might be more difficult to become internet besties with these bloggers, since they get a lot of attention and a lot of time requests from a large audience, but be thoughtful and helpful in your outreach, including links and social mentions, and eventually your "betters" in the photo-blogging totem pole will start to take notice of your work, as well.

As you start to establish your place in the great hierarchy of the blogosphere, guest posts can be another great way to offer help to others and derive mutual benefit. A guest post is simply a post on a blog written by someone other than the blog's main author. These kinds of posts can be a great way to send traffic back and forth between two related blogs with different audiences, thereby growing the audiences of both blogs. A guest post can be a great way to dispense some unique knowledge you possess, relate a unique anecdote, or share a unique image. Find a piece of content that is special and valuable, and offer to share it with another blogger's readers; all you need to benefit from the arrangement is a link back and a byline.

As you network, keep in mind the lyric: "The love you take is equal to the love you make." In other words, be sure you're giving as much value, respect, and time as you're getting from others. The more you give, the more likely you are to receive—that goes for simple things like backlinks, Twitter mentions, and blogrolls

Get to know folks at your own level, then gradually work your way up.

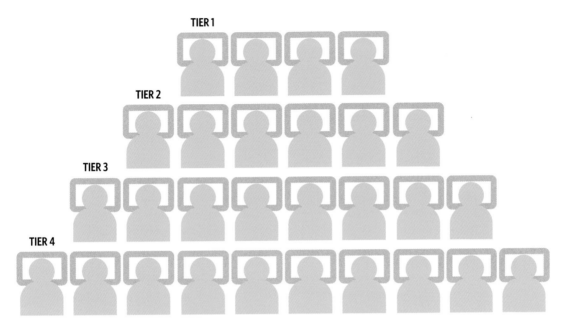

TIER 1

TIER 2

TIER 3

TIER 4

as well as more significant opportunities that may come your way as you continue to blog, such as podcast invitations or speaking engagements.

Wanting to "climb" the ranks of the web is only natural, but do so without using others and do so with a constant eye on how you can give back to other, even newer bloggers. It's good sense, good manners, and good karma.

In addition to networking "up" within your own niche of photo blogging, it can also be useful to network "across" other niches. For example, if you write a blog on live music performance photography, get to know local music bloggers who frequent the same venues and shows. If your photography business and blog are all about weddings, get familiar with the scads of wedding bloggers out there. Food photography and food bloggers are another good matchup; ditto for fashion/editorial work and the gazillion fashion blogs online. The universal appeal of a beautiful image makes your work more cross-over worthy than most.

The Great Hierarchy of the Blogosphere
Tier 1: Internationally famous professional photographers, photoshop gurus, and industry spokespersons
Tier 2: Professional photographers and other creatives, with big followings in specific fields
Tier 3: Amateur photographers with small followings, but active in the photo-blogging community
Tier 4: Readers & commenters

A great way to get in good with these bloggers is to simply forward them a few photos and sentences about the images, giving the blogger in question express permission to republish your content with a link back to your own blog. Bloggers are always on the lookout for good content, and great photography is a huge part of what gets these writers the traffic they need to stay in business.

75

social networking for your blog

In many ways your blog is just the beginning— a hub, of sorts, that connects all your other various online personae.

Before the social-media era, creating a community of readers used to take a lot more work. One had to pound the virtual pavement, network with more popular bloggers, and do a lot of rather complicated self-promotion to build up an audience that would consistently return to read and view one's work online

These days, finding that community is a lot easier. And if you're creating great, useful content and speaking with an authentic voice, getting those existing communities interested in your blog can be as simple as training your personal megaphone in a couple new directions.

As we've already discussed briefly, the wonderful world of blogs is a very social place these days. Activity on your blog itself will actually represent but a small part of your audience's reactions and interactions with and around your content. Much more conversation will be occurring around the web at destinations such as Twitter, Facebook, Pinterest, Instagram, and Google+.

Of course, it helps if you've already built up a personal and/or professional audience on a few social networking sites. But even if you haven't, you should start using social networks to grow your audience and increase your stature in the larger online community of photography.

You may already have personal profiles on a number of these services, but depending on the name and scope of your blog, you will likely want to set up new profiles and pages for your blog. Make sure your new profiles have names and URLs that match the name and URL you so carefully chose for your blog— you don't want readers getting confused!

While creating new profiles for yourself as a photographer and photo blogger might seem like extraneous work, it will help vastly with your personal/public persona separation and work/life balance in the future. Think about it: You might already have a personal Facebook profile, where you connect with friends, family, and even co-workers. However, not all your acquaintances tied to this profile will necessarily want to read about your latest gear or a new technique you're trying out. Unless all your Facebook friends are also photo geeks, you would be well served to build a new Page that's all about you as a photographer. On these Pages, you accumulate "Likes" rather than developing mutual friendships, and you can feel free to toot your own horn as much as you like without annoying your too-cool-for-school nieces, who have no idea what you're blathering on about, anyhow.

The most important thing to remember is that insofar as you're using social media tools to get more readers for your blog, your online profiles should always, always link back to that blog—even to specific posts relevant to the topic of the day. In any profile you create, there may be space for you to add a link to your personal website. If your blog is a chief concern, let that link direct readers to your blog rather than a static website or even a portfolio. You can always allow your

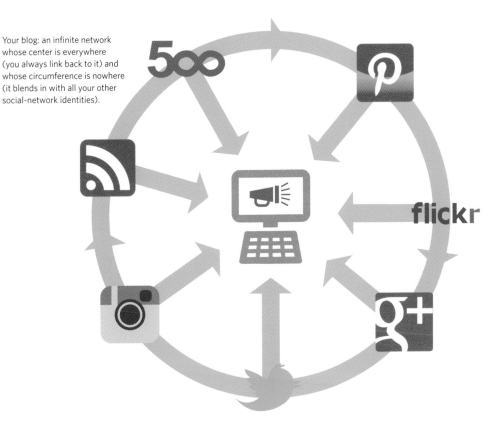

Your blog: an infinite network whose center is everywhere (you always link back to it) and whose circumference is nowhere (it blends in with all your other social-network identities).

blog to direct interested parties back to your portfolio, but the blog will let your audience know what you're interested in and talking about right now—and when it comes to online content, there's certainly no time like the present.

Social media communities are very sensitive to timeliness, so whether you're interested in current events or other hot-button issues raised by photo bloggers or others in your online world, you should be tying your work to timely and relevant topics whenever possible. Keeping your content somewhat linked to what's going on in the world around you will boost your traffic and also ensure that others are linking back to you and sharing your posts within their own networks, as well.

Two of the most important tools you'll use for social networking are Twitter and Facebook. Which site

ends up being most important for you will largely depend on your specific audience and your blog's analytics. That is, once you start promoting some of your pictures and posts on those networks, take a look under the hood of your blog and see where your traffic is coming from. If you've got more traffic coming from one source or another, hypothesize and test for what factors might be making that network more profitable, and then optimize for those factors.

For example, if you find that lists of photography tips perform really well on Facebook, start cultivating a few ideas for similar posts, and promote the published posts on Facebook during high-traffic times of the day. If one-off gallery snaps get a lot of action on Twitter, be sure to promote those posts on Twitter and ask your audience to share and retweet them.

Each network has its own advantages. Twitter allows you to reach out to and be found by those with an explicit interest in the art of photography through its Lists feature and through user-driven follow recommendations. One meme in particular, called Follow Friday and abbreviated as #FF on the site, gives users a weekly opportunity to recognize and recommend Twitter users whose updates might be relevant to a specific group. Use #FF to shout out to influential photo bloggers you might want to know. If someone else mentions you in a #FF update, be sure to thank that person.

Facebook has tons of Groups and Pages devoted to photography. Here, you'll find a less decentralized but more easily distracted community. Use photo-focused Groups to your advantage, but take care to act as a helpful participant, not just a rabid self-promoter—this is a good rule for all social media interactions.

Both Twitter and Facebook have built-in photo-sharing tools that provide potential readers with a colorful and visual sneak peak at your content. Each time you create a Twitter or Facebook post, make sure that a preview of your photo is available with a link back to your original blog post.

At the time of this writing, Google+ is still a fairly new social network. However, by far one of the biggest groups using it frequently and successfully is—you guessed it—photographers and their fans. In fact, the phenomenon of shutterbugs taking over Google+ became such a big deal that an entire conference in 2012 was devoted to photography and photo blogging on Google+.

Flickr is another great way to showcase your work and direct readers back to your blog. The site allows you to add other users as contacts, friends, or family; it also has a built-in messaging system. For any serious photog, whether professional or amateur, it's highly advisable to spring for a Pro account, which costs around $25 annually. The expense allows you to host as many photos as you want; non-Pro accounts cap the number of pics at a paltry 300MB.

As with all other social networking tools, be sure to link your Flickr photos to any blog post that might be associated with those photos. In the caption for each pic, you'll have an opportunity to add text. While not every photo needs to be a blogged photo, you should be including relevant links back to your blog when the photo in question reveals a previously blogged technique, is part of an ongoing photo challenge, or has been used in your blog somehow.

If you use a smartphone, mobile photo-sharing tools such as Instagram are great ways to instantly give your online friends an idea of your eye and inspirations when you're out and about. While you might not be using your mobile photography consistently in your blog, your "moblogging" profiles should still serve as links back to your blog and should help to create more interest in your as a person and in your life as a photographer.

Pinterest is a fascinating tool for sharing and curating images. Each "board" on the site is a collection of thumbnails that link back to the image's original source. You can and should set up a Pinterest account of your own for highlighting fascinating shots and new techniques you find around the web. Also, you can search the site for your blog's URL to find out who's sharing your work around Pinterest.

When curating your Pinterest boards, focus each board on a specific subject: Inspiring landscapes, gorgeous portraits, lighting techniques, to-try tutorials, etc. And don't fill a pinboard with your own work, either; Pinterest is best used for building an audience through great curation, then slipping in your own shots, blog posts, and tutorials every once in a while when they deserve the extra traffic.

Finally, your LinkedIn profile can be a great, more professional social networking tool for not only increasing your blog readership but also boosting your business, if selling your work or booking paid gigs are things you'd like to do. The best thing about LinkedIn is that it allows you to bring an RSS feed for your blog directly into your profile.

TEN TIPS ON SOCIAL NETWORKING FOR YOUR PHOTO BLOG

1. Post your pics directly to the network in question rather than posting only links back to your blog. It's a great way to start conversations without having to type up a whole blog post.

2. Frequently mention and connect with other photographers, linking back to their profiles and their work, and well as commenting, sharing, and "liking" or upvoting their photos.

3. Share links from a variety of sources, not just your own blog. Pick content from other bloggers and other websites that you think will be educational, interesting, or entertaining for your audience. This will establish you as a source of great information rather than just a self-promotional bore.

4. Strike the right balance. Tweeting once every hour might work for some celeb-bloggers with huge audiences; tweeting just a few times a day might be right for you. Experiment and optimize for great conversations.

5. Be engaging! Respond to comments, reply to questions. The best part of social media is the rapid-fire, back-and-forth conversations you'll have with fans of your work and other photographers.

6. Do not duplicate. Unless you're sharing a link to one of your blog posts, try to not post the same images or text to all your networks at the same time. For example, share a mobile photo on Instagram, ask a thought-provoking question on Twitter, take a quick poll on Facebook, and share a high-quality photo on Google+.

7. When you're sharing an image, especially if a thumbnail won't be visible right away, be sure to write a great description or caption for your image. Readers will be likely to show interest in something like, "Amazing food from amazing locals at a Puerto Rico food stand [image]," rather than, "This is awesome! http://t.co/ul8e0."

8. Every now and then, remind your Twitter followers that you also have a Facebook page, or your Facebook fans that you have a Google+ page, et cetera. Just a gentle nudge every month or so should do the trick.

9. Even if you're just sharing a quickie mobile upload, share your best work, and make sure the quality is something you'll be proud of in the future. If high-quality, high-resolution upload options are available, use them always.

10. Understand that sometimes, your readers may download and repost socially shared images without your permission. Unfortunately, this is just a casualty of the internet in its current form. Don't try to get around it with watermarks or worse, ugly tirades and lashing out. Take the high road, and trust that your best work will usually be linked back to you.

5 *monetization*

Whether you decide to monetize your blog and how you decide to do so depends on your audience, why they read your blog, and how big a crowd they comprise. For example, if the entire point of your blog is to drum up new business for your photography studio, running advertising on your blog would probably be distracting and counterproductive for your business goals. Selling prints from your blog might be a much better option. On the other hand, if you started a blog for networking and find that you're reaching a huge readership, there's no reason not to run advertising. Your blog only needs to be a money-maker if you want it to be, and you should always feel comfortable with the brands or products you work with or sell.

Here's the bottom line: What you do to make money with your blog should be in harmony with your blog's content, focus, and audience. If your monetization strategies and your blog itself are in alignment, you can't go wrong. As much fun as blogging (and making money) can be, remember that you're a photographer first and a blogger second. Blogging should make you happy, even if it doesn't make you rich. If trying to monetize your blog is giving you fits, focus on the parts of photo blogging that make you truly happy, instead.

advertising

TURN YOUR PASSION INTO PROFIT

As I've mentioned, ads are an obvious choice for making money from your blog. This solution isn't for everyone, but it can be a set-it-and-forget-it way to start your monetization plans.

Generally speaking, more traffic means more money from ads, so if you're getting a couple thousand visitors a month, you may not see much in the way of results in your bank account. However, if you've got a steady, robust traffic stream of more than 1,000 visitors per day and plans to keep that count growing, ads might be the right choice.

You can set up one-off deals with companies that might want to advertise on your site; these can be simple to set up if you're comfortable with your CMS and website skills. However, the returns for single-ad deals can be minimal, making chasing those deals time-consuming and ultimately unprofitable. Rare opportunities may come along for you to partner one-on-one with a great brand for a fair fee, but I recommend a more automated approach.

AD NETWORKS

Ad networks are another way to get started with putting advertising on your blog, and these networks are as numerous as the stars in the firmament. They range from big players you may have already heard of, such as Google's AdSense and Federated Media, to specialized networks just for niche blogs and websites. There are even ad networks that make offerings for specific blogging software, such as WordPress and Blogger.

So, with all these options, how do you pick the right one (or ones)?

Automated services and ad networks can save a lot of time, but still give you plenty of data to track and respond to.

First, go through your blogroll and find out which sites have ads. Snoop around a bit to see where those ads are coming from. There might be a link hidden in a sidebar or menu, or you might see something way down at the bottom of the page. If you dig around a bit and still can't find out where the ads come from (and if you're looking at a particularly popular blog), just do a web search for something like "advertise on

PhotoBlogName.com"—that could give you some accurate and informative results.

As you continue your research, take note of how the ads look and feel. Are they ugly? Distracting? Irrelevant? Or are they pleasantly designed and harmonious with the other content on the blog? The answers to these questions will further narrow down the list of ad networks you may want to work with.

Then, for simplicity's sake, find out if certain networks already have integration features for your CMS. This could make the process easier in the short term, in particular.

The networks you find through your research may be particularly relevant to your niche; they may or may not be right for your blog, depending again on how much traffic you're getting. Traffic in online ads is measured in thousands; you'll earn a given CPM (cost per thousand; the M is a Roman numeral) for each ad space that appears on your blog. If your readership is low, your ad revenue will be low. However, ad networks also frequently have their own internal promotional mechanisms to promote traffic across all their own publisher sites, meaning that joining a certain network when your pageviews and visitors are low could lead to higher pageviews, more visitors, and potentially even some loyally returning readers if your content is of good quality.

Once you make those decisions, the technical part of ad setup could be as easy as copying and pasting some code in an HTML widget in your blog's sidebar. Or it could mean copying and pasting some code into your blog theme's code—which you might not have easy access to. Or it could be a lot more complicated than that. Understand at the outset how much technical heavy lifting you'll have to do to integrate any given ad network, and be prepared to call in professional help if you get in over your head and are still committed to running ads on your blog.

"Born in May of 2009, PetaPixel is a blog about photography geared towards tech-savvy photo-enthusiasts. Our goal is to inform, educate, and inspire in all things related to photography.

In case you didn't know, the 'peta' in PetaPixel is the prefix that denotes 1015, just as the "mega" in megapixel denotes 106."

- PetaPixel.com

Not as math-intensive as that description might make you think, Petapixel gets a lot of coverage in the photo blogosphere for its impressive mixture of up-to-date news stories and well researched perennial posts with lots of great advice for photographers of all skill levels. It's a group effort—the "fantabulous" team consists of Michael Zhang, Jessica Lum, and DL Cade. Among them they cover everything from photo industry news, to legal and intellectual property advice, to new gear and technology pieces, and even some historical posts of interest. They also have advertising and partnerships that aren't intrusive in the reading experience, and even a small store where you can download knicknacks like iPhone skins and camera stickers.

working with brands

FORGE A PARTNERSHIP

One way to get cash and equipment without (or in addition to) running advertising on your blog is to work directly with brands.

The brands could be huge companies like Canon or Adobe; they could be mom-and-pop shops or small online stores. But if you're open to working one-on-one with corporate entities, you can open up new revenue streams that are still very closely aligned with your photo blog's goals.

If your blog is getting a lot of traffic or the right kind of traffic from influential voices in the world of photography and photo blogs, you might get emails from brands directly. But getting started with brands, especially brands that meet your own criteria, might require a bit of outreach on your part.

First, you'll want to find brands that are a great fit for your blog and your niche. Think about your content. Do you write and/or shoot a lot of equipment tutorials? Do you offer photo-editing tips and tricks? Do you work with models and modeling agencies a lot, or is there a particular type of client you serve? What's your

favorite, go-to brand for cameras, lighting, software, or even computer hardware? Is your audience composed of amateur shutterbugs, professional photographers, or entertained enthusiasts?

The answers to these questions can help you build a list of industries and specific brands to reach out to. When you send the introductory email or make a phone call to a brand, be sure to include a few important details, including traffic for your blog (daily, monthly, or weekly), the type of content you create, and the type of person who reads your blog frequently. If your blog has an active community on social networks and in comments, definitely note that as well!

And always have in mind at least one specific option that can provide money for the brand and an interesting and profitable opportunity for your blog.

SPONSORED POSTS

Sponsored posts are one obvious way to work with a brand. In a nutshell, a sponsored post is an informative, evergreen (i.e., not time-sensitive) post that centers on a specific topic and for which you receive compensation from a brand.

Sponsored posts generally take a bit of legwork on your part, either hands-on experience or online research. The topics will have to be agreed upon in advance with the brand, and the posts may be cross-posted on the brand's own blogs, websites, and social media profiles.

When choosing potential topics, keep your audience in mind. If your audience is mostly composed of photographers, you'll need to create posts that are informative and valuable to a photographer. If, on the other hand, your audience is composed of "civilians," you'll have to take a different tack. E.g., if your blog is about wedding photography and your audience is mostly soon-to-be-wed consumers, you might have less success with a sponsored post on outdoor lighting techniques for photogs and more success with a sponsored post on must-have wedding-day shots for brides. The only way to know which group your audience falls into is to build and interact with your community on a daily basis.

One of the most important parts of sponsored posts is transparency—that is, your readers have the right to know that you got paid by a company to write that post. Even if the post is totally neutral or doesn't mention the company or its products, put in a small disclaimer that explains the post is sponsored by a brand. And even with the disclaimer, remember to keep your writing, recommendations, and reviews neutral, fair, and accurate. It's okay to partner with a brand; it's not okay to be a mindless corporate shill.

For example, imagine your blog is all about running a small photography studio. You might establish a relationship with Intuit, a software company that makes tools for accounting and bookkeeping. As part of this relationship, you could run a series of six posts on how to manage money for a small photography studio. One post might focus on setting up software; another might focus on billing. The posts will be based on your own personal experience as well as research you've done on the topic. They may mention Intuit's software, but if other software is better for a particular task, you'll mention those programs, too. And of course, at the beginning or end of each post, in italics, you'll be careful to note that the post is part of a series sponsored by Intuit.

PAID REVIEWS

Paid reviews are tricky territory. Being compensated in any way—even if you just get free hardware, software, or other products out of the deal—pretty much throws your objectivity out of the picture.

However, if you work hard to maintain a neutral and accurate tone and comments, and if you accept the fact that some readers are going to think of you as a biased source of information regardless of how neutral you try to be, then paid reviews might be an option for you.

Paid reviews are closely related to sponsored posts, but instead of evergreen topics, you'll be focusing on timely products that are hot right now. You might even get to play with as-yet unreleased toys, such as the latest beta version of Adobe Lightroom or an upcoming camera from Nikon.

You might be compensated in product alone, or you might get paid per review post. Whatever your arrangement with the sponsoring brand may be, you should be sure to include a transparency statement with each post, outlining what you received in exchange for the post (a product to review and/or monetary compensation).

Also, be careful to state that the compensation didn't have an impact on your review—and be totally, absolutely sure that this statement is true! Giving a glowing review about a shoddy product hurts everyone, including the brand and your readers, in the long run. If you run into problems while testing out the product, you can let the brand know and give them a chance to respond; but don't avoid letting your readers know about problems or potential issues they may have if they purchase the same product.

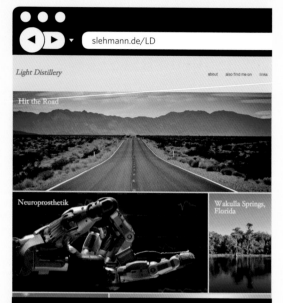

"This little project originally started in 2008 as 'Colors Inc' and recently changed to 'Light Distillery' (as of March 2012). It is just a selection of captures I have taken within the last couple of years, but mainly from 2007 on. Interesting to see some learning process going on...Photography is a fascinating field without any borders, both for motives and techniques. I am learning every day and would be more than happy about critical comments regarding my pics."

- Sebastian Lehmann
Light Distillery

Based out of Germany, but with photography from all over the world, Light Distillery has a slick design (built on WordPress) that makes for a lush environment in which to view Sebastian Lehmann's stunning imagery. It's clear that the photography comes first here, but descriptions attached to each image post augment it from the typical photo blog and provide insight into the mind of a talented and creatively developing photographer. Sometimes the comments are technique-oriented, sometimes they're fun behind-the-scenes info; but they always make the whole blog feel personable and inviting.

CONTESTS AND GIVEAWAYS

These are an excellent way to boost interest and participation—people love free stuff!

Here's an idea that readers will love: Work with a brand to stage an online contest. You come up with the challenge and act as contest judge; the brand will provide the fabulous prize or prizes. Or you could just get the challenge part out of the way and host an online giveaway instead.

While you'll still have a disclaimer that the prizes are being provided by a brand, you won't have the responsibility of writing reviews, conducting research, and maintaining neutrality.

Contests and giveaways work best when you have a large, active, robust community. The better your community, the better the prizes you can get.

Another option, if you do photography for clients and have a lot of non-photographer consumers reading your blog, is to have a brand sponsor a photography package, including any travel expenses you may incur.

Half the fun in any contest or giveaway is the creativity and promotion—you don't necessarily need thousands of dollars of prizes to make it worthwhile and interesting to your readers.

The better your community, the better prizes you can get.

BRAND AMBASSADORSHIP

**Is there a brand you love so much that you'd be
willing to sell out to them without thinking twice?**

Do you already know the company and its products
inside and out? If you're a big-time fanboy or fangirl
of a particular brand and are known as such by your
readers, it may be worthwhile to ask the brand to work
with you as an ambassador or evangelist for their
products, news, and overall image.

So, what does a brand ambassador do? You'd have
the inside track on that company's products and news,
perhaps even getting invited to special parties, being
sent to launch events or trade shows, getting advance
demo units for new products, and more, up to and
including a paycheck.

In return, you'd probably run some advertising for
the company on your blog. That brand would probably
expect you to write a few sponsored-type posts for
them from time to time, as well as reviews. And you'd
be tweeting to and otherwise updating your community
with messages from and about that brand. Essentially,
in addition to being a photo blogger, you'd also be
a part-time marketer for a company in your niche.

Because of the deep saturation that brand would
have with your own online brand, these can be tricky
waters to navigate. Be absolutely certain that the brand
is a perfect fit with your audience and content. Also do
your own research to be sure the brand doesn't engage
in any practices you find objectionable.

However, the moment you become an official
ambassador online for a particular company, you are
not able to be neutral or objective in your reviews or
opinions about other company's products or services.
As previously mentioned, if you're already known to
your community as a huge Nikon fangirl, for example,
your community won't be expecting you to come out
with a glowingly positive review of a Canon. So in that
case, being a Nikon brand ambassador won't hurt
anyone. But if you're not already a Nikon fangirl, taking
on brand ambassadorship pretty much makes you one.

And as always, the key word is still transparency.
No matter what your arrangements are with that brand,
be sure to note that the relationship exists and that you
receive compensation or other special considerations
as an enthusiast or evangelist for that company. Make
this disclosure in specific posts as well as on your blog's
"About" or "Contact" page.

*Be certain that the brand is a perfect fit
with your audience and content.*

"I intend to provide interesting, useful info about mobile devices, Photoshop, Flash, design, photography, and related issues. My job title is Principal Product Manager at Adobe, and my gig involves building next-gen creative imaging apps for mobile devices. My underground clubbing title is DJ Telnet. (Note: I don't actually do any clubbing, underground or otherwise. But hey, I like the title.)"

- John Nack

OK, we can't all be the masterminds behind Adobe products, but John Nack's impressive blog does a great job of illustrating the role of a blog in promoting and supporting a business or corporate product. For one, it's important to note that even though it's hosted by Adobe blogs, it's not the official mouthpiece of Adobe at all. You'll quickly see that the blog is far from your typical bland corporate-speak business blog—it's got Nack's personality all over it, and it goes far above and beyond promoting Photoshop. He is active in the photo blogosphere and frequently engages the community when they have concerns or questions. It's also just a great blog on its own—regularly updated, with innovative techniques shared and lots of interesting links to other photography-related content elsewhere on the web.

"See, I am a 'photo enthusiast' as well as a passionate photographer. I love what I do so much that over the years I realized I was trying out a TON of camera gear searching for the holy grail. With all of my experience using this gear, in February of 2009 I decided to put up a site where I can write about it all, and this is the result! With this site I want to show YOU how this gear performs in the real world. I will also share with you my processing tips, photography tips, where I buy this gear, my photo projects and jobs that I get along the way."

- Steve Huff

Photographer Steve Huff has that whole preserve-your-own-voice thing that we talked about down pat. His enthusiasm for both the craft of photography and the gear that supports it is extremely evident and highly contagious. It's clearly working for him, as his blog has been steadily growing in popularity for a number of years. His often-entertaining posts are punctuated with stellar images, and he uses his blog to promote his own workshops, in addition to advertisements and site sponsors. He also keeps up the momentum by inviting guest writers to share their own posts from time to time—which are excellent too.

selling your stuff

YOUR OWN PHOTOGRAPHY

It doesn't take a corporate partner to make money online.

As any Etsy seller or Kickstarter hero can tell you, there are usually a few people out of the hundreds of millions of internet surfers who are actually willing to pay you directly in exchange for your own unique goods and services.

For physical goods in particular, you'll have to consider the overhead costs for manufacturing your own merchandise. Before you put any time or money into creating physical goods, make sure your community will support that kind of commerce; conduct a quick poll of your readers, asking how much they'd be willing to pay for physical goods and what kinds of goods they'd most like to buy from you.

Setting up an online store is another technical adventure you'll have to complete in order to sell your goods or services online. The services you'll use will depend on what you're selling. If you're booking a photography class, you can use a ticketing service like Eventbrite to sell slots and manage attendees. If you're selling an e-book, you could set up a new WordPress/Paypal integration and page to charge for and deliver the PDF or link to your customers. Or, if you go all-out and start selling a wide range of items, you could set up a whole storefront, either from your blog's CMS or from a social site like Facebook or from a separate website altogether. It all depends on how technical you want to get, whether you're willing to pay for someone else to do the technical heavy lifting, and what kind of stuff you're selling in the first place.

PRINTS

For photo bloggers, the go-to goods of choice are prints. Selling prints of your most popular photos can be a lucrative and simple way to get started with blog monetization. In fact, quite a few sites exist that will allow you to set up your own photography print shop and sell directly from your blog. Take a look at Photoshelter.com, Fotomoto.com, and Shotproof.com for examples of online photo-print stores that are dedicated to photographers.

You can also sell notecards, postcards, calendars, stickers, or vinyl decals featuring your images, either selling them online or printing them at home and shipping them out as orders come in. Some photographer-friendly sites will feature printing and distribution services for these kinds of items, as well.

Many online printing businesses already exist and are eager to partner with you to distribute your images. It's worth researching your options and seeing what particular deals each service offers.

BOOKS AND E-BOOKS

If you're a true expert in a particular niche or technique, you might do quite well by writing, photographing, and publishing a book or e-book for an audience of photographers.

In addition to putting a few coins in your pocket, writing an informative, thorough book can be a huge help in building your credibility in the photography community, especially if your book is well researched and offers valuable insight on a unique issue, technique, or type of photography.

Self-publishing a hard-copy book means you'll have to take on all the costs of printing and promoting your masterpiece; it also means you'll get to keep all the profits. Just make sure your community wants and will pay for a hard-copy book before committing to the expense of publishing one yourself.

On the other hand, the only cost to publishing an e-book is your own time and effort. Granted, creating an e-book on your own can take quite a bit of both resources! However, the return on your investment can be substantial, especially if you have a large community, are an acknowledged expert in a topic, and/or have unique knowledge to share.

E-books can be found online for prices ranging from free to $20 or more per book. Your own prices should be based on what your own personal market—your readers—will bear and should correspond to the length of the book and the amount of effort that went into creating it. Again, conduct a quick poll of your readers on what topics they would like to read about and how much they'd pay for a virtual book on those topics.

Your content should be extremely practical for photographers, whether you're writing for beginners or advanced pros. Many of the best-selling e-books serve as guides to tricky areas of photography, such as photographing children, working at night or in low light, or graceful and effective post-processing. Other, shorter guides can focus on overarching themes such as renewing one's creativity or continually improving one's photography.

While writing and photographing for your book, try to have at least one other person look over the text and images before you publish it. More eyes are rarely a bad thing in publishing. Export the finished document as a PDF, or use an online service such as Issuu.com to upload your text and images in an interactive, web-based format.

Once your book is finished, promote it on your own blog and social networks, and ask blogger-friends to promote it, as well! Sending around review copies can help a lot in getting the word out about your new book. It also wouldn't hurt to publish a small section or chapter of the book on your own blog as a teaser to entice prospective buyers.

Check out the numerous online training services that can package up your quality content and make it easy to distribute.

ONLINE EDUCATION

If you are truly an expert in your field, you can consider creating an online course or workshop for a particular technique. These kinds of offerings go beyond an e-book; they're more in-depth, and they generally contain video content, even if it's just a screenshot video with narration.

These courses can sell for any amount you find reasonable. For shorter modules with a narrow focus on a single skill or technique (e.g., chiaroscuro portraiture), you could charge $5 for a course. You could also bundle together a few courses on portraiture lighting and sell the bundle for $25. Or, you could go all-out and create a three-day-long workshop full of courses on lighting

techniques and equipment, call it "Lighting Essentials for Intermediate Photographers," and charge $150 for the package. Again, it depends on who your audience is and what they're willing to pay for.

Online services such as Knoodle.com, Pathwright. com, and Traindom.com can help you get your videos, text, images, and other content organized into beautiful and user-friendly courses, which you in turn can sell and promote from your photo blog.

hosting live events

BLOGGERS EXIST IN REAL LIFE, TOO!

If all that uploading, video, and blog-based marketing isn't your bag, you could consider doing live classes, workshops, or photo walks.

For live events, make sure you give your readers a ton of advance notice; since your online audience is geographically disperse, you'll need to give yourself extra time to promote and organize an in-real-life meetup. In addition to promoting your event online, you'll also want to reach out to local photography groups, community colleges, and your local blogging community.

For all live events, make sure equipment requirements are clear for anyone attending or registering for your class, and remind folks to bring backup batteries and chargers.

If you've been networking with other local photo bloggers, consider pooling your online resources and hosting a community event together. You can increase the size of your audience, create more valuable live content, and give attendees a wealth of diverse knowledge, areas of expertise, personalities, and perspectives.

Keep in mind, though, that transitioning from the comfortable distance of online relationships to the very real, up-close, and in-person world might bring a bit of awkwardness from time to time. Remember to exercise common sense: Don't meet up with strangers at or near your residence, and don't give away too many personal details. These folks are your audience, your fans, even—but they're still strangers. Be friendly and personable, but don't bring anyone too close until you've gotten to know him or her a bit better.

Live events can have a cascade effect on your readership—initial online involvement leads to active real-life participation, which feeds back into a healthy discussion on your blog, and anticipation of future events.

San Francisco Botanical Garden Photowalk

Saturday, September 29, 2012 from 2:00 PM to 5:00 PM (EDT)
San Francisco, CA

Ticket Information

TICKET TYPE	REMAINING	SALES END	PRICE	FEE	QUANTITY
General	24 tickets	Sep 29, 2012	$13.00	$1.32	1

PayPal BANK AMEX DISCOVER MasterCard VISA **Order Now**

Who's Going

Oops! We're having trouble connecting to Facebook. Please try again.

SHARE THIS EVENT ✉ Email Share Tweet Like Be the first of your friends to like this.

When & Where

San Francisco Botanical Garden

San Francisco, CA

Conducting a workshop or class may seem daunting, but with enough prior preparation and practice, it can turn into a lucrative side business of its own. Be sure you have enough content to fill the allotted time, and be sure that you have enough time to pay attention to the attendees who have signed up. If you've got a larger online community than you have locally, you can also consider offering discounted tickets for webcasts of your workshop or class.

Especially if you're a popular photo blogger living or traveling in or near a photogenic area that attracts a lot of visitors, hosting a photo walk can be a great way to make money and meet and interact with your community. Photo walks are what they sound like: a walking tour with an emphasis on photography. These events often occur in beautiful natural settings, such as parks or gardens, or in trendy, architecturally interesting historic or downtown areas.

Since group photo walks are often free events, however, you'll want to bring something unique and valuable to the experience—something worth paying for, even if you're only asking attendees to pay $5 or

To make sure your participants get their money's worth, be sure to plan out all the details carefully, and have some contingency plans. Then publish the itinerary with plenty of time for feedback. Lots of online services exist to help you organize everything in an attractive visual package.

$10. This could be on-the-fly instruction or tips, access to a non-public area (you could get group-rate tickets for a botanical garden, for example), or having a pre- or post-walk talk or panel discussion.

After the photo walk or workshop, be sure to follow up with a blog post and images from the event, including images from your attendees!

Use an online event or ticketing service such as Eventbrite to set up your event, sell tickets, get relevant information (such as maps, times, locations, materials, etc.) to attendees, and update your group if and when changes occur.

95

affiliate marketing

A SOFTER APPROACH TO PARTNERSHIPS

Affiliate marketing can take a fair amount of time, and it's advanced stuff for the beginning blogger. Still, many bloggers swear by this method and end up making a decent living from affiliate marketing.

A word of caution:

Affiliate marketing can sometimes take your readers to unpredictable places. Like all online marketing, affiliate marketing has its share of unsavory scam artists. Every now and then, you may find an online retail site committing financial fraud, using the site for lead generation (collecting contact info from your readers) rather than sales, or even not delivering products once your readers have ordered them. Do your research about programs and networks that interest you; make sure they're interested in selling actual products, not your readers' personal information. Never pay a fee to join an affiliate network, and establish human-to-human contact with your affiliate manager as soon as possible after you do join.

Most important, simply be sure you can devote the time and effort to running an affiliate site before you sign yourself up. Affiliate marketing is a serious business and a way of life for a subsection of online professionals, and doing affiliate marketing as a main source of revenue can take up a lot of time and require a lot of expertise. You're already a photographer, either as a hobby or as your profession; be sure you can balance the demands of running a money-making blog, too.

Briefly, affiliate marketing is a process by which you get paid each time someone clicks from your blog to a partner website and makes a purchase. There's no relationship between you and the retailer or brand selling the item; affiliate marketing can be conducted through huge networks of blogs and websites.

One of the more interesting aspects of affiliate marketing as a photo blogger is that you can use your affiliate marketing to promote software, books, and equipment you blog about, including reviews and tutorials. If there's a tripod you absolutely love and want to recommend, you might already be linking to a retail site where your readers can buy the tripod. Affiliate marketing just means you'd get paid for that recommendation if any of your readers follow through on your advice and buy the tripod for themselves.

The whole thing works with long URLs containing special codes. Retailers create a unique URL for each affiliate site or blog; that's how they track which affiliate site sent over which customer. And every time a customer makes a purchase, the affiliate gets a financial kickback from the retailer.

Many bloggers see affiliate marketing as a way to promote the things they love and would promote anyway, and to do so in a way that remains true to and contiguous with their content. It benefits you, the blogger, by providing much-needed revenue. It benefits your readers, who want to know how to get the latest, greatest cameras, lighting gear, editing

When it works, it's a scenario in which everybody wins: Your reader gets the product they want; your affiliate gets the sale; and you get a slice of the pie for connecting the two.

software, etc. And it benefits online retailers and brands, who want to reach out to the people who really want and care about their products.

Not every post needs to or should contain affiliate links; after all, you're trying to build a photo blog, not a spam blog, and readers can definitely tell when they're being given the hard sell. Just use the affiliate links when you'd naturally recommend a product. You can even pop affiliate links into Facebook posts or updates on Twitter or Pinterest, if you like! But don't let affiliate links clutter up your social streams, either.

One of the easier ways to dip your toes into affiliate marketing is to check out Amazon and eBay's affiliate marketing programs. You can also look at multi-retailer networks; Referred Media and Commission Junction are two popular affiliate marketing networks. Skimlinks is a simple option for many bloggers; it finds product mentions or other relevant text already in your blog posts and converts those text words into affiliate links, taking your readers to retail sites around the web and earning revenue for you without your having to do too much about it.

On the technical side, many networks and programs will offer special plugins and widgets for popular CMSes, as well. But since affiliate marketing for your photo blog is likely going to be based on text links, not sidebar ads, the technical setup is pretty simple: Sign up with an affiliate program or network, then start putting those links into your text. Affiliate marketing will be most profitable if you already have a steady stream of traffic and if you understand and practice good search engine optimization in your day-to-day blogging activities.

As with all advertising and marketing relationships, do disclose to your readers that you're doing affiliate marketing on your blog, either in the posts that include affiliate links or in your blog's "About" page.

6 inspiration

As a photographer, you may at times feel creatively stifled.
As a blogger, you will definitely feel sometimes like you simply run
out of pictures to share or things to say about those pictures. Half the
battle as a photo blogger is keeping the whole pursuit interesting for
yourself. Staying fresh, motivated, and inspired is its own challenge,
but the rewards are invaluable, both for you as an artist and for you
as an online media creator. Preventing creative stagnation can seem
like a Herculean endeavor. The way to start is to create small, daily
creative tasks for yourself, and make sure you're giving yourself lots
of opportunities to be inspired and motivated by others.

A few years ago, I was going through a phase of deep depression and
felt unable to create anything as a writer, designer, and photographer.
Even getting back on the creative path felt impossible. But by setting
up a simple challenge—a month of art assignments—I made daily
creativity into a little game I played with myself. With each mini-
assignment I completed, my skills improved and my creative mind
woke up a little bit.

Here are a few ideas to get you out of a rut or to simply keep you
mentally active and creatively engaged through your photo blog.

photo-a-day challenges

A PERSONAL CHALLENGE AND A POPULAR THEME

They guarantee a steady flow of posts, provide incentive for your readers to check back every day, and challenge you to improve your skills—what's not to like?

One of the simplest ways to challenge your creativity and sheer endurance as a photo blogger is to pledge to post one photo each day for a given period of time, generally one month to one year. These photo-a-day challenges can be self-imposed; however, many photo-sharing sites or photography groups will begin daily photo challenges around specific milestones such as the beginning of a new year.

When you decide to take on a daily commitment to creating and posting photos, you're not just deciding to do something for yourself; you're also making a very public promise to your readers. Once you claim that challenge, there's no going back! And sticking with your daily photo-posting commitment will enrich your life, boost your creativity, and at the end of the challenge, give you something tangible of which you can be proud.

Reasons to take on a daily photo challenge range widely and often depart from simply wanting to create a daily photo post. Perhaps you have realized you don't post as much as you'd like to, and your blog traffic is suffering as a result. Perhaps you feel like you're in a creative rut. Maybe you just don't have as varied or extensive a portfolio as you want to have. Worse still, you might be lacking inspiration or creative desire.

A photo challenge, in these cases, is a lot like taking one's medicine. Mustering the willpower, brainpower, and heart to create art day in and day out can seem like an exhausting and daunting task—and some days, it will be. But if you continue to take the proverbial medicine, even when you're busy or uninspired, you'll be surprised at how surely your creative ailments vanish.

"Shutter Sisters is committed to honoring and celebrating the beauty that women behind cameras can capture. We embrace the belief that we are all creative equals, eager to share with one another our work; our art. It is in that sharing that we thrive and grow not only in our creativity but in all facets of our lives. As technology continues to vigilantly lay down new stepping stones in our exploration of the ever-changing landscape of photography, each day offers a chance to learn more."

- *ShutterSisters.com*

The Shutter Sisters are twelve talented photographers who have gotten a lot of attention in recent years for their innovative approach to a group photo blog. Each sister has her own particular area of interest, and together they round out a truly impressive array of topics, from photojournalism to iPhoneography and everything in between. They invite a lot of reader participation in the form of workshops, photo challenges, prompts, discussions, and link love. There really is something for everyone to find here, and the regularity of posts make it a regular stop for their huge and growing audience.

Everything about Rebekka Guðleifsdóttir's work screams authentic and creative. After gaining attention for her photography on Flickr, she decided to step it up and establish on online presence, supported by her blog in which she describes in great detail her creative process that goes into each of her works of art.

Indeed, it's the attention to detail that makes her blog stand out—far more than a series of camera settings and studio setups, she explores the psychology of creativity and doesn't shy away from a lot of personal reflection in her posts. This confidence in revealing her own thoughts invites commentary, but it's the end result—her images—that elevate the blog and make it something special.

Naturally, her blog ties in with the other parts of her life, from a sweater-making business to an online shop from which you can order high-quality prints of her work. It's a courageous blog, and knowing the thought process that goes into each shot makes it very easy for readers to click on the order button.

First, decide how long you want the challenge to last. If you don't think you have the stamina or the consistency to commit to a year's worth of daily posts (and most of us don't!), try starting with one month, ten weeks, or 100 days. The specific length of time is arbitrary; simply choose a time period that will allow you to accomplish your personal, creative, and blogging goals.

Second, especially for shorter challenges, you might want to decide on a theme or focus for your daily photography. Ideas for these themed challenges abound on the web. A month of portraiture can get you in front of a lot of fresh faces, and photographing

people is a surefire way to inspire those others and their friends to take an interest in your blog and your work. You could use the images as a way to tell a specific story or series of stories, or to explore a new city or neighborhood. The motif could be concrete (25 pictures featuring the color red), abstract (50 images about happiness), finite (30 photos taken inside your house), or conceptually up for interpretation (photograph your way through the alphabet). But the themes should always give you something to sink your teeth into, something slightly challenging to execute.

Third, every day, try to do something new with your photography and/or your blogging. Learn a different

skill, explore a new face or location, try a new photo editing technique, or explore new storytelling methods. After all, the challenge isn't just about pure tenacity; it's largely about forcing a creative growth spurt.

And on that note, not every day necessarily has to be a photo-shooting day. Although you've pledged to post one image per day, you can shoot photos a few days a week and take the other days to experiment with other elements of your craft, such as editing and blogging. As long as you're creating output and flexing your intellectual and creative muscles at least once a day, you're in good shape.

Photo-a-day challenges work best when approached genuinely—you may have decided to do it in order to generate content, but the main impetus is personal improvement and creative exploration. If you treat it as such, your readers will be more engaged and appreciative.

The themes should always give you something to sink your teeth into.

photo walks

GET OUT AND EXPLORE

Getting yourself physically out into the world with your camera has a great effect on your creativity. It also works as a group activity because you'll all have something to keep busy with.

In the last chapter, we briefly touched on the idea of photo walks as a possibility for hosting a live event as part of monetizing your photo blog. But less formal photo walks can be an amazing way to connect with other creative folks, explore a new location, and search for scenes, people, and things that inspire you. These happenings literally pull you out of your world and into a new setting, making them particularly great for those times when you feel bored, trapped, or in a creative rut.

Practically, you'll need to prepare for a hike and a mini-location shoot at the same time. On these walks, be sure to wear comfy shoes, apply sunscreen, pack a snack, and be prepared to walk around for as long as it takes to get a picture that satisfies you. Bring only the gear that's comfortable for you to carry around. And bring a map, especially if you're going to be in an area without smartphone or GPS service. If you're photo walking in a group (and most photo walks are group activities), be respectful of others' shot set-ups and try not to accidentally "photo-bomb" another photographer's shot. And this goes without saying, but don't photograph innocent bystanders without asking for their permission.

When you're planning a photo walk, pick an interesting location—a verdant park, a natural history museum, a historic neighborhood, a wooded hiking trail, a busy fashion district, a seaside cliff, a bustling ethnic neighborhood—someplace that will offer all kinds of opportunities from portraiture to still-life macros to landscapes. Don't head into the photo walk with a preconceived idea of what you're going to photograph that day; instead, wait for serendipity and circumstance to show you new views and perspectives you might not have seen otherwise. Stand in one spot and look all around you, 360 degrees, scanning slowly for something that piques your interest.

Images from photo walks and longer photo excursions are greate for illustrating narrative posts. If your camera has a GPS feature, it's worth investigating what options you have to visually represent that data on your blog.

Photo walks can be a great time to overcome shutter shyness or try out new styles and techniques. Because of the casual, free-flowing nature of the activity, you're not under any real pressure to create; you're not working for a client or on a deadline. You can make mistakes, so make lots of them now! Play around and have fun; explore new settings and objects from a range of angles. You could even use a photo walk to break in a new camera—try film or toy cameras, new lenses, or other equipment.

If you're a solitary type (or, like me, just a deeply shy introvert), you might try taking a photo walk by yourself for starters. If you're an extrovert and naturally derive energy from being around others, meet up with other local photogs you might know from blogging or from your social networks and head out into the world to get inspired together. Use Facebook or Google+ to set up a date, time, and meeting place, and meander as a group.

Being around other photogs is a great opportunity to ask questions, get technical advice, share creativity tips, and expand your network and knowledge. You might even consider ending the photo walk with a stop at a cafe, tea shop, or bar to rest your feet, share your images, and enjoy time with your fellow creatives.

Photo walks can be great one-off events to rally your spirits and your local community of creatives; they can also be wonderful periodic events to explore your area fully over the course of a year or longer. And if you feel particularly ambitious and particularly comfortable with your photo walking group, consider planning a photo field trip to another fabulous location, perhaps a bit farther away from your home base than usual.

One benefit of a group photo walk is the opportunity to trade and experiment with other people's gear—particularly if you are shooting with the same system.

www.PekkaPotka.com/Journal

PEKKA POTKA
photographer / digital artist / writer / consultant

Home Portfolio Blog Samples Forum Contact CV Potkastudios

OLYMPUS M.ZUIKO 17MM F/1.8
NOVEMBER 14, 2012 AT 19:48

I think it was Homer Simpson who said: "35mm is a way of life, 35mm is my way of life, and I aim to keep it." Maybe he just didn't mention explicitly 35mm? D'oh, anyway, I do mention and I mean it. 35mm lens is my way of life. 35mm lens lends my way of seeing the world to my images. Now 17mm is the new 35mm as I shoot with Olympus OM-D. Cameras may change but 35mm way of photography was the same for me in the '70:s.

Search

Blog index (Journals)

Olympus M.Zuiko 17mm f/1.8
Copying slides with OM-D and 60mm Macro
Olympus E-PL5 beats OM-D hands down!
Or?
Olympus M. Zuiko 60mm f/2.8 Macro
Olympus 15mm f/8 - Working the Dog and
Having Fun

November 2012 (3)
October 2012 (4)
September 2012 (4)
August 2012 (5)
July 2012 (1)
June 2012 (4)
May 2012 (3)
April 2012 (3)
March 2012 (3)
February 2012 (6)
January 2012 (3)
December 2011 (4)
November 2011 (2)
October 2011 (1)
September 2011 (1)
August 2011 (2)
July 2011 (5)

This Finnish blog (with a parallel blog written in English as well) found a valuable niche in the micro four thirds platform, specializing in Olympus gear. His reviews are thorough and frequent, covering pretty much all the most popular products in a timely manner—such that his reviews are frequently linked to from many other blogs and forums, and referenced as authorities on their subjects. You can tell that a lot of thought and care goes into each review as well, both in the practical, down-to-earth feedback he gives on each camera and lens, and also in the huge number of quality images he produces for each post. Indeed, what begins as a competent technical review often ends with an impressive gallery of photos from a variety of genres.

Pekka Potka stands out as an example of finding a niche audience and catering to it well—the micro four thirds platform was brand new when the blog started in 2009, and seizing that opportunity has clearly paid off, as waiting for a Pekka Potka review of a newly released product has become a standard part of the Olympus fanboy/fangirl experience.

ImagesFromTheEdge.com/blog

Niall Benvie. Clay Bolt. Paul Harcourt Davies. *Pictures and stories about wild nature. And us.*

More than just nature photography.

Home Book Niall for a talk Books Worth Reading Bruno d'Amicis: Italian Posts Copyright information Doing business with us Essays Image search Macro Matters PhD Orchid Tales: PhD Professional profile Quote Niall on this Technical articles Workshops with Niall

Uber cool new hide/blind. NB
Posted on December 10, 2012 by niallbenvie

Search

During my farming days, many years ago, I learned the art of improvisation, of making do with what's at hand. And there is a particular pleasure to be had from doing this, especially when circumstances demand it.

Take, for example, those palletised 1000 litre plastic tanks in a metal cage used for the transportation of liquids; you'll often see them about farms these days (if you're thinking "how the heck am I meant to get hold of one of those?" I've actually seen them advertised secondhand on eBay...)

Archives
• December 2012
• November 2012
• October 2012
• September 2012
• August 2012
• July 2012
• June 2012
• May 2012
• April 2012
• March 2012
• February 2012
• January 2012
• December 2011
• November 2011
• October 2011
• September 2011
• August 2011
• July 2011
• June 2011
• May 2011
• April 2011
• March 2011
• February 2011

Three professional UK photographers teamed up in 2009 to exhaustively cover their area of shared interest: nature photography. Niall Benvie, Clay Bolt, and Paul Harcourt Davies each have impressive resumes behind them, but in the end, Images from the Edge adds up to even more than the sum of its parts.

There are many interesting product reviews—not of every new camera, but rather of particular products relevant to their readership, like macro and field studio equipment. There are loads of posts detailing professional techniques, with lots of stories from the road and behind the scenes that offer insight into the way these working professionals think and approach their craft. And there are captivating pontifications of what nature photography means to this group.

Importantly, Images from the Edge is also an excellent platform for self-promotion, as all three photographers use the blog to plug their new books, sell workshops, or book professional services. It's even better than offering up your portfolio—in a way, you get to know the personality of these photographers before you ever work with them or read their books.

create a project post

AN EASY EXIT FROM A CREATIVE RUT

Whether it's a DIY project with lots of documentation, or an exploratory shoot in a given setting, these posts are a straightforward way to create interesting visual content.

When you've got a creative block, nothing seems that interesting to photograph or blog about. Creating a project post is one way to find the one activity, setting, social issue, or person that seems even moderately interesting to you, then going to work on that project, treating your topic as your muse.

This kind of challenge isn't about mastering new techniques or formats. It's simply about reigniting your passion for photography using your existing passion for some other part of your life.

For example, if you just moved into a new place, you could make photographing your neighborhood and even your new neighbors into a project, conducting mini-interviews to flesh out your blog post. If you really care a lot about animals, make the local animal shelter part of your project; go photograph volunteers, kittens, dogs, turtles, etc. and build a narrative blog post around it.

The project doesn't have to be photojournalistic in nature; you could explore new faces in a portraiture project. You could try getting editorial and artistic with a fashion project. If you like a particular type of music,

try finding a few performances and creating a project around the performers, venues, and fans of that genre.

Like the photo-a-day challenges, a project post can and should have a theme that fascinates you. Unlike the photo-a-day challenges, you'll only be doing one post, and it may take more than one day to finish it.

Since this project post will take a bit of effort to conceptualize and shoot, treat the post like a big, glossy magazine feature where you get to be the photog, writer, and editor all in one. Lay out the photos interestingly, in full-width format or in galleries, and give them unique, story-telling captions. Schedule the post to go live when your traffic tends to be highest, and promote your project around your social networks. Be proud of the results, and start thinking about new projects you can concoct to boost your creativity using your other interests.

An explore-the-neighborhood project comes with its own built-in theme, and can serve as an excellent introduction of yourself to your readership without involving too many personal details.

It's about reigniting your passion for photography using your existing passion for some other part of your life.

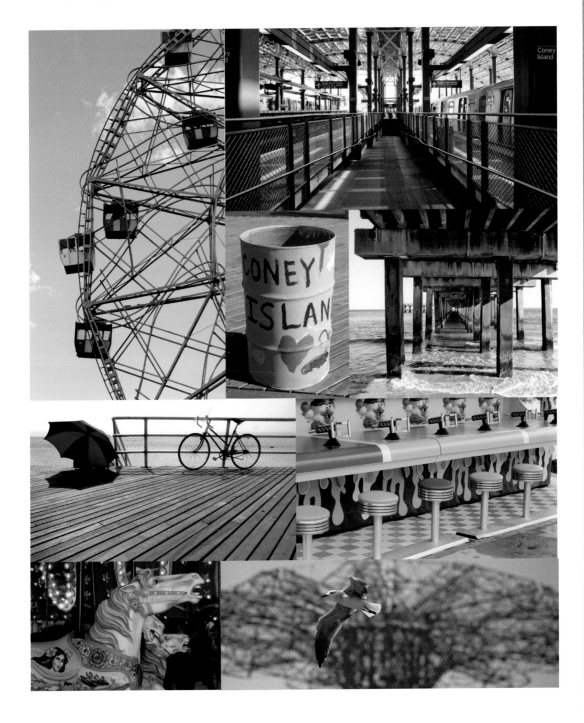

inspiration from other arts

Photography benefits from its ability to piggyback off of a wide variety of art forms, and your blog can do the same.

As a photo blogger, you can find artistic illumination and a lot of blog posts when you immerse yourself in other art forms. A trip to a sculpture museum, a night at a rock concert, even a sneak peek backstage at a community theater can offer many opportunities for great pictures and great stories to go along with them.

The one rule for using other artists as inspiration is to only photograph the kinds of art you truly love. If you're not inspired by oil paintings, don't wander into an oil painter's studio and expect lightning to strike. If you only like opera, don't convince yourself that a reggae show will make you feel more creative. Pick the arts and artists toward which you naturally gravitate; your passion will show in your photos.

When you pick a medium or artist, try to find a scenario that will afford you better-than-average access to your subjects; be able to get up-close and behind-the-scenes to get better images and a better story for your blog post. When necessary, use your blog as leverage. For example, if you're into sculpture, ask a museum curator if you might be allowed to photograph objects that aren't on display to the public, explaining that you run an online publication about art and creativity and will be posting a feature on the "underground" collection for your readers.

If you're photographing a live performance, this is another circumstance where running an online publication will be vastly to your advantage. Use your blog as credentials—to get a media pass! Especially if you have decent traffic, you can usually meet most of the requirements for gaining media credentials. At the event page, browse around to find a press or media section, then find contact information for a media liaison or an online application for a press badge. See if you meet the requirements for taking images in special areas, including orchestra pits or backstage.

If you can't get good access to live performers at their events, try shooting them in other scenarios. Live performers, including both popular and classical musicians, dancers of all stripes, and actors, always need more quality pictures of themselves. Get them in costume and in performance mode in visually striking settings, and be sure to include whatever instruments or props you think will be visually interesting.

Aside from captive collections in museums and live performers, there's a world of visual art out there. Find a local artist or two and ask for permission to tour and photograph the studio or other workspace to capture a ceramics master at work, a plein-air painter creating a masterpiece, or a glassblower transforming molten glass into delicate baubles.

And if traditional art forms aren't your cup of tea, definitely go off the beaten path. Look for circus performers, fire dancers, independent filmmakers, performance artists. Even in the adult worlds of burlesque and cabaret performance you can manage to find interesting, self-aware, and inspiring artists.

110

Whatever you do, be sure to collect information along with your photographs, learning interesting tidbits about the artists you encounter and the art they create, which you can later share with your blog readers.

Much of the time, these types of post will come with plenty of backstory, letting you round out your photos with behind-the-scenes details and narratives that add interest and invite commentary.

create a themed challenge or competition

Especially if you're doing your fair share of community-building on your blog, contests can be a wonderful source of inspiration as well as interaction. Contests (or challenges, if you prefer to keep your community non-competitive) can bring your readers, commenters, and online friends out of the woodwork to share their own creativity with you and each other; in those moments, your blog becomes more than just a website about you and your photography and becomes a hub for people who are inspired by your work and who want to inspire each other, as well.

To create a challenge or contest, start by announcing it on your blog. Tell your readers you're conducting a competition or exhibition around a theme; name the theme, giving a few examples, and ask readers to make their own submissions. As submissions roll in, give readers opportunities to see and talk about the photos in galleries or exhibition blog

Photo for a Halloween-themed challenge.

posts. At the end of the challenge or contest, finish up with a final post about the winning or notable entries and what you learned or how you were inspired in the process.

Themes can be timely or timeless. For example, you could announce a photo contest for images about motherhood right around Mother's Day. Or you could challenge your readers to submit their best images about brotherhood at any point during the year.

The topics you could choose are almost endless. For your first challenges, try to focus on themes of interest to your audience and that fit well with the rest of your blog's content. For example, if you run a children's portrait studio and blog a lot about photographing kids, you could run a contest for images about misbehaving kids.

Seasonal challenges (e.g., "winter portraits," "summer fun," Halloween scenes) work very well for online contests; because your readers are likely already taking pictures of thematically appropriate material, asking them to submit their best images for that season or holiday doesn't require too many extra steps on their part. They don't have to schedule a new photo shoot; they just have to dig through the images they already have and love.

Frédéric Bernard Payen's french-language blog has a clear technology and gear-review focus, which helps establish himself in that particular niche and gets plenty of interest from his readers.

What makes it even better than your standard review site is the depth he goes into in describing ideal workflows, backup systems, image organization, media maintenance procedures, and more. You can tell he has a real flair for the techy side of things—many of his posts are illustrated with simple and straightforward diagrams to help get his point across. In the end, you end up trusting his reviews because of his authority on these areas of interest; plenty of people can tell you about Photoshop or Nikon's latest DSLR, but not everyone can tell you the ins and outs of solid-state drives and exactly how they can boost your image-editing software's performance (for one example).

But it's not all techy stuff—there's a solid vein of photography enthusiasm running through every post, with lots of reader involvement in the form of guest posts and contests. Payen reviews a large number of quality photo books, and includes links to his own portfolio of great photography that speaks for itself.

Especially if your community is smaller or not made of professional photographers, consider going with a "mobile" theme, showcasing the best of smartphone photography. Thanks to better smartphone cameras and mobile photography apps, all kinds of people are being exposed to photography tools, and most have no training, formal or otherwise, in how to frame and shoot beautiful images. Take that onslaught of new amateur photogs as an opportunity to find and show off tasteful, interesting, well-done mobile photos on your own blog.

Once you've declared your theme, set out very clear, specific rules and guidelines, especially if this challenge will be a contest with a winner named at the conclusion. Are adult-themed submissions okay? What about digitally manipulated images? Is even the lightest Photoshopping to fix levels verboten, or will you allow for extra post-production special effects? In the rules,

set a cut-off date for challenge submissions; if you're running a contest, also let readers know when the winner will be announced.

If at all possible, establish a prize or prizes for the winner or winners of your contest (no prizes are required for non-competitive challenges). The prize could be a brand-donated item, such as a gift certificate for an online photography shop or a fun smartphone camera lens from an iPhone accessory maker. Or you could purchase a prize yourself or "re-gift" a new (still in the box, still with all its tags) toy for your fellow photogs. In some cases, an interesting vintage item might make a great prize—think about Russian toy cameras or old Polaroid cameras from the mid-century period. Keep in mind that if you're offering a physical prize, you may have to ship it overseas.

Finally, give your readers clear instructions on how to submit their photos, and make sure that submission process is extremely simple and that you, yourself don't have to take too much action to keep the submissions rolling in. For example, you could leave the comments section of your blog open and ask readers to post a link to their submission photo in the comments.

Also, let readers know if and where their images will be featured. Will you post a gallery of the best pics on your blog? Will you create a Flickr set with the submissions? A Pinterest board? Have a plan for publishing and promoting the images in your challenge or contest.

Next, get your community really involved by sharing the contest announcement blog post on Facebook, Google+, and Twitter. Every so often, revisit those social networks with an update, such as a notable new submission or a reminder about the challenge's end date.

If your challenge is competitive, consider taking a vote as the contest nears its conclusion. Pick the best three or five images, and use your CMS's polling function or a separate polling widget such as PollDaddy to tally votes from your readers. As an added bonus to the voting approach, finalists will drag their online friends over to your blog to vote, thereby increasing your blog's traffic; if your content is good, some of those new visitors might stick around.

When your challenge is over, be sure to write a blog post about the more notable entries, linking back to the websites or social profiles of the entrants. And of course, if your challenge is a contest, contact the winner and blog about the winning photograph, including notes or anecdotes from the photographer.

Inviting participation from your readers is always an excellent idea, but you should prepare for any such projects by making any rules clear and easily available in order to ensure that the whole process is orderly.

Besides being fortunate enough to snag an excellent URL (it helps being a German blog and using the .de domain extension), Lens Flare delivers a lot of personable, quality content in a down-to-earth style that ensures it's easy to approach and enjoyable to read.

It's the hobby side-project of Steffen Göthling, a web developer from Berlin, and Besim Mazhiqi, a freelance journalist and photographer. Together, they cover all the big photo industry news stories, sometimes with commentary. Reviews of popular products are featured, with informative feedback that doesn't get too bogged down in the details. They also offer a lot of general reflections on the role of photography in their own lives—often reported from the road and on their travels.

However, a big thing that sets Lens Flare apart is its impressive number of giveaways and contests. It's clear these guys work hard to secure sponsorships and partnerships with various businesses, and that relationship pays off with prizes that entice readers to return frequently and participate enthusiastically.

115

photo-blogging muses

FINDING INSPIRATION

Finally, when the creative life has been sucked out of you entirely, you need your secret, never-fail resuscitator: a list or feed of photographers around the web and image-oriented bloggers who make you think, "Oh, I want to do that!"

For many photogs on the web, their secret muse has become Flickr's bucket of noteworthy recent images, found at Flickr.com/explore/interesting. For you, it might be a Pinterest board you or someone else has curated and refreshed with great pics from great photographers. Or it might be a Facebook page about photography.

Your muse list should almost certainly include a few bloggers, as well—perhaps some of the sites from your own blogroll. It could also include blogs from outside the photography niche, such as a music blog or a cooking blog or a fashion blog, anything that features images and topics that leave you feeling energized and refreshed.

Make sure this list includes a decent range of styles, both in text and images, and some diversity in its layouts, for individual posts and for the publication as a whole. Set up your list as an RSS feed, a list of Twitter accounts, or just folder of browser bookmarks, if you don't feel like getting too technical. You could also share your secret list with your readers as a blogroll-esque sidebar or widget of inspirations.

My own list includes the way over-designed but brilliant publication The Bold Italic, a great resource for local San Franciscans. I also love The Pioneer Woman for butter-based cooking and fun photo treatments, and I frequently browse over to blogger The Vintage Vixen for fashion and style notes. I also keep tabs on the websites of some of my design-

blogger friends in town or musician friends across the country. These aren't photography blogs per se, but they all feature images, themes, and other elements that inspire me. They are some of my muses; they make me want to go out and create.

Figure out what online people and blogs and sites and resources make you want to get off the internet and go be creative, then save those links carefully for the rainy days when you need the extra lift.

You can elevate a casual browse of your favorite sites to a creative research project simply by keeping a notepad next to you (digital or physical) and jotting down notes and ideas as you look around. Not everything will result in a massively successful blog post, but they will get your creative juices flowing.

the Bold Italic

READ · TALES FROM SAN FRANCISCO
DO · A BOLD EVENTS CALENDAR
SHOP · NEIGHBORS WE LOVE

Sign In | Sign Up

HOW TO CONQUER APARTMENT HUNTING

Sam Harnett gives tips on finding an apartment during SF's toughest rental market

GET OUR NEWSLETTER

SIGN UP

LET'S BE FRIENDS
Stalking us is easy. Like us on Facebook.

Like 4.5k

TWEET BEAT
Want instant gratification? Follow us on Twitter.

Follow

LATEST AND GREATEST

THE BOLD ITALIC & SM PRESENT:
Gift Shop *free*
DEC 1 - DEC 2

HOSTED BY THE BOLD ITALIC
The Bold Italic + Stag Dining Group Present: Holiday... *$125*
DECEMBER 15

2nd Annual ClemenTime Microhood *free*
DEC 6 - DEC 6

HOSTED BY THE BOLD ITALIC
The Bold Italic & Dusty Stax Present: Winter Won... *$40*
DECEMBER 8

The Dinner-Party-In-A-Box
GET IT

The Bay Brewed 2012 *$30*
DEC 1 - DEC 1

SHOP SAN FRANCISCO CREATIONS

DISPATCHES DAILY UPDATES

EVENTS BOLD EXPERIENCES

A PEEK INSIDE RELIQUARY

The Bold Italic's Pop-Up Shop in Downtown Oakland
NOV 20 - JAN 5
HOSTED BY THE BOLD ITALIC

2nd Annual ClemenTime Microhood
DEC 6 - DEC 6
HOSTED BY THE BOLD ITALIC

The Pioneer Woman

PLOWING THROUGH LIFE IN THE COUNTRY...ONE CALF NUT AT A TIME

HOME · CONFESSIONS · COOKING · PHOTOGRAPHY · HOME & GARDEN · HOMESCHOOLING · ENTERTAINMENT

Subscribe via: E-Mail · RSS

Search The Pioneer Woman · GO

I'm a desperate housewife. I live in the country. I channel Lucille Ball, Vivian Leigh, and Ethel Merman. Welcome to my frontier!

About · Contact

Find the Pioneer

Recently on ThePioneerWoman.com

Blueberry Lemon Sweet Rolls
Nov. 30, 2012 in Cooking
First of all, I need to state for the record...

Cheddar Tailgating Bread
Nov. 30, 2012 in Tasty Kitchen
I hope you're in the mood for something fantastically...

Community Question: Tips to bring out the best wor...
Nov. 29, 2012 in Homeschooling

The Best Skillet Ever (Winners Announced)
Nov. 28, 2012 in Cooking

American History up to 1850: Presentations & Curr...
Nov. 28, 2012 in Homeschooling

Prepositions!
Nov. 26, 2012 in Homeschooling

Inside ThePioneerWoman.com

Dreamy Apple Pie
Heavy cream baked with the apples makes this Thanksgiving pie unbelievably rich. A dollop of hard sauce sends it over the top!

Pumpkin Smoothie
It's ridiculously easy to whip up...and one of the best things you'll ever taste in your life. Try it and see!

No-Knead Dinner Rolls
The rolls I make for Thanksgiving are no-fuss and low-effort. Not kneading required! Amen.

Thanksgiving Stuffing
Cornbread, sausage, and these gorgeous cooked apples are the star of this show in my favorite Thanksgiving stuffing.

Pumpkin Soup
Creamy, dreamy, delicious pumpkin soup. So smooth, so delectable...you won't be able to control yourself!

Leftover Turkey Spring Rolls
It's never too early to plan for leftover ideas!

Find the Pioneer

Faux Twix Pink

Gift Ideas!

The holidays are coming—hooray! Here are some of my favorite gift ideas I've featured in years past (and some new ones, too) I'll add to the list regularly between now and Christmas.

Read

Buffalo Chicken Salad

Everything that's delicious about buffalo wings...but in salad form!

Read

A Charlie, Charlie Christmas

Charlie has a new Christmas-themed book! It chronicles the day a cat enters his life...and all the chaos that erupts.

Read

Full Recipe Index

Check out the Visual Recipe Index on The Pioneer Woman Cooks...

Read

PW Links

About My New Cookbook!
About Pioneer Woman
About Photos and Giveaways
Contact
Details on the PW Show
Food Network FAQ
Full Audio Clips
Links to Other Cooking Sites
Links to Other Sites
My Lockdown!
PW on Facebook
PW on Food Network
PW on Land O'Lakes!
PW on Pinterest
PW on Twitter
Tasty Kitchen!
Ten Important Things I've Learned About Blogging
Top 10 Favorite Baby Boy Names
Top 10 Favorite Baby Girl Names

Great Sites

Simply Recipes
Three Many Cooks
In Pursuit of Happiness
Family Fresh Cooking
Mercashly
I Am Baker
A Thought for Food
Frannie Cooks
Steamy Kitchen
Clotilde / Mimi Design
This Unlettered Cottage
Bake at 350
Big Mama
The Nesherry
Kevin and Amanda
Joy the Baker
Picky Palate
Homesick Texan
Bakerella
The Shiksa in the Kitchen

Charlie Books!

Here's Charlie's book funi!

The new Christmas-themed Charlie book will be out this fall and introduces a new friend for ol' Charlie. Hilarity ensues!

My Cookbooks

My new cookbook is filled with fun recipes, good food, glorious food. Hope you enjoy it!

Chicken fried steak, mashed potatoes, apple pie, and pancakes. My first cookbook has all the good things in life.

© Copyright 2006-2012, The Pioneer Woman | Ree Drummond. All Rights Reserved
Powered by WordPress

BlogHer Publishing Network

flickr · from Yahoo!

Home · The Tour · Sign Up · Explore · Upload

You aren't signed in · Sign In · Help

Search

Explore / Interestingness / Last 7 Days

Get more interesting photos from the last 7 days · RELOAD!

trims
From the little red hen

Steppin' Lightly "Explored"
From slackfoam

summer daisy
From {SBL}980}

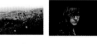

En haut del la ville de FUNCHAL
From LiLi296...

Untitled
From soulcoaster69

1 World Trade Center, Sunday afternoon
From Jay Fine

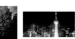

Central Park Explore 646
From LWPhotographer2012

Glow in the dark, Shanghai, 上海
(EXPLORE 27-11-2013))
From Bievo (Zippy's back)

Autumn in Stowe Landscape Gardens (Bell Gate Drive (3))...
(Explore Front Page!) - Thank you so very much!))
From migny1

The photos you see here are a random selection of some of the interesting things discovered on Flickr within the last 7 days. If you click the RELOAD! button you'll get another set of random spinnies.

RELOAD!

About Flickr · Community · Help · Apps and the API · Follow us

taking a break

GOING OFF THE GRID, RESPONSIBLY

Even the best bloggers sometimes need to give it a rest. The trick is knowing when, how, and for how long.

When you have too many projects going on at once, and one of them needs to give way or you might lose your mind, that's a great time to take a blogging hiatus. When your family or your health needs your attention more, that's a sign it's time for a break. When the internet is stressing you out and your community is hurting you more than it's helping you, you can step away. And when it stops being fun, you don't need to be doing it.

The big thing to remember is to let folks know you'll be offline for a bit. Try to give them an idea of your timeline. If you need a two-week break, tell your readers you'll be back in two weeks; if you need to get offline indefinitely or quit blogging altogether, let your readers know that, as well.

It's tempting when you're stressed to just bolt, leaving no trace behind you; however, as insubstantial as those online relationships may seem, you have established some kind of bonds with people who can't see you from day to day and who will wonder if you're all right should you evaporate into the digital ether. Giving some kind of notice is almost always a must.

If you're worried your community won't be too pleased with your vacation, you can ask fellow bloggers to step in with some guest posts, offering whatever revenue or traffic you can in return.

And if you're going on an actual vacation, let your downtime be true downtime! Unless it's a photo-blogging excursion, there's no need to photo blog while you're supposed to be relaxing. Schedule a post or two, let your readers know you'll be away from a computer having a fabulous adventure.

Based in Spain, professional photographer Rafa Irusta maintains an excellent blog that he runs parallel to a dedicated professional site. In it, he details the nuts and bolts of his professional business, which take shape in many different kinds of posts—some are simply lush image galleries with basic shooting info attached in captions; some are workflow technique posts explaining how he keeps all of his images organized and recommending certain naming and keywording systems; others are stories from the field (it helps that he travels a lot) in which he sometimes reviews products on the fly as he puts them through the paces.

But significantly, you're only ever one click away from his main professional site, where you can order prints or books (both physical and electronic), get in contact for services, or simply browse extensive galleries. Rafa also teaches group photography courses—the schedules of which are published on the site—and offers private lessons on landscape and wildlife shooting.

Running one of the most popular Italian-language photo blogs, Marco Crupi posts on virtually every aspect of photography possible—attracting a wide and diverse audience. He's often the first to post Italian reviews of popular new products, and even when he can't get to a product, he usually at least links out to another competent reviewer. There's also an abundance of perennial content, from a running gallery of historically important photos—each with relevant commentary—to complete guides to techniques like HDR, and even a general Nikon-versus-Canon catchall that's a long-running favorite.

This comprehensive approach is frankly intimidating, and takes a lot of dedication; but the result is creating a website that becomes a regular stopping point for bloggers, particularly if you establish yourself in a certain market (Italy, in this case—though it's worth noting that he also runs an English-language site at http://www.mcdigitalphotography.com/). It takes a while to build up this kind of site, but once it reaches a critical-mass point, the momentum can really take hold.

119

7 photoshop basics

When posting your images to the web, you'll want to make a few adjustments—the file sizes will be smaller, files types will be different, and you may add a few extra bells and whistles to turn a nice image into a beautifully designed illustration for your written blog content. Here's a quick run-through of how to use Adobe Photoshop image-editing software to your best advantage as a photo blogger.

Before we begin, note that it's best to edit your images lightly and without degrading the original. You'll do this by adding layers and making adjustments to the layers rather than to the original photo file. It's a bit like making copies of a photograph and modifying the copies rather than doing anything to the negative; you can play to your heart's content with the ability to start over, if you need to. Any time you want to make a change to your image, make that change in a fresh layer. You can toggle the eye button to show and hide the changes in order to help you make better editing and design decisions. If you decide a particular change wasn't the right route, just delete the layer, and the mistake will vanish along with it.

And of course, save your work early and often, especially if you find yourself using unreliable hardware or software!

adjusting brightness

Brightness is often the first step of any post-production work—fixing the exposure and optimizing it for your subject.

Brightness is one of the quicker fixes you can accomplish in Photoshop, and there are quite a few ways to complete the task using layers that won't degrade your original.

To start adjusting brightness using adjustment layers, first open your JPEG image file. Click Layers in the top menu, then Adjustment Layers. Immediately, you'll see quite a few options for making changes to the brightness and contrast of your image. **[1]**

Each layer type will produce a slightly different result; play around with different types of adjustment layers to get a feel for how each one affects your original. You'll likely end up using different settings for different issues in your original photograph.

The most obvious solution is to create a new Brightness adjustment layer. Click the Brightness and Contrast button in the menu. You'll be prompted to create a new layer; if you're using more than a couple layers to edit your image, you might want to choose a distinctive and accurate name for the layer, such as "Brightness" or "Darken." **[2]**

Next, you'll see two sliders appear for your new layer. These will allow you to make the image brighter or darker with more or less contrast **[3]**. Again, you can toggle the adjustment layer on and off with the eye icon to see your changes; the original JPEG itself will remain unchanged. **[4]**

Note that with these kinds of adjustment, a little goes a long way, and a lot can easily look ham-fisted

in the end. Make conservative changes and subtle corrections. If you think your images need more heavy-handed editing, it might be time to invest in your behind-the-camera technique rather than your in-front-of-the-monitor skills.

[1]

122

[2]

[4]

[3]

Before

After

Another adjustment layer you can choose is called Levels. When you create this layer, Photoshop will let you stretch and shift the image's histogram—that is, the graph that shows where the digital data in the JPEG is distributed.

If you move the center slider to the left, the image's mid-tones will grow lighter; if you move it to the right, mid-tones will grow darker. You can also move the left and right sliders to adjust the black and white points, respectively. But again, subtlety with this tool is key. A poorly compressed or stretched histogram can lead to an amateurish posterized look in the final product.

Before

After

A Curves adjustment layer is perhaps one of the best ways to change the brightness and contrast in your image. It allows you to stretch and compress tonal curves, either for all the colors in your image or for the red, green, and blue channels individually (which can be great for making color adjustments or adding interesting effects to your photos).

Again, you're changing the histogram of your image, so tread lightly when you're in Curves. If you need a bit of brightening to your image, create a new Curves adjustment layer, then look at the graph it creates: a straight diagonal line. Click in the middle of the line to create a new point, and pull that point just a bit up and left; you'll see the image grow brighter as the point moves.

For more brightness and contrast as well, try making two points and creating a subtle S-curve in the graph. To darken the image or diminish contrast, just invert the curve or S-curve instead.

Before

After

ADJUSTING BRIGHTNESS WITH LAYER BLEND MODES

Another way to tweak your image without degrading the original JPEG is to duplicate the JPEG in a new layer, then change that layer's blend mode and opacity.

Before

First, open your JPEG as a new PSD Photoshop file. Next, locate the Layers window in the bottom left corner. Right-click on the original image layer, then select Duplicate Layer. **[1]**

Click on the new layer, then look at the drop-down menu directly above it. This menu will let you control the blend modes, that is, how the two layers interact with each other. Originally, the top layer is set to a Normal blend mode, so it appears opaque, as if you had just stacked two printed photos on top of each other. Other blend modes, however, will give the top layer

[1]

After

some transparent qualities with interesting and often useful results. **[2]**

To darken the image, change the top layer's blend mode to Multiply or Color Burn. To create a lighter image, try Screen or Color Dodge. If you'd like more contrast, choose a blend mode like Soft Light. And adjust the top layer's opacity as well, moving the slider to the right to achieve a subtle effect.

This blog takes the Photo-a-Day challenge we've discussed previously and pushes it to the limit. Granted, it helps to live in as photogenic a place as Paris, but here you'll find a lot more than your typical tourist shots of the Louvre and the Eiffel Tower.

ParisDailyPhoto goes out of its way to distinguish itself from your regular photo-a-day blog, though. Such blogs often have great photography, but hardly any supporting commentary. That can make it easier to keep up with regular posting, but as you can see at ParisDailyPhoto, by including a simple paragraph about what's going on in the shot, the history of the location, or even a tidbit about Paris life that isn't directly relevant to the content of the photo, you can elevate a series of images into something much more—a blog that invites attention, commentary, and return views.

It also attracts advertisers—but not of the photo sort. ParisDailyPhoto wisely capitalizes on its main subject by captivating the travel audience, which is of prime interest to a wide variety of advertisers, from plane ticket sales sites to hotels and car rental services.

[2]

127

Ps

adjusting color

You'll soon find that color is a much more subjective quality than brightness—but with time you will also get comfortable with your own style & workflow.

On to color adjustments! Once again, it's best to have the accurate color in your original image because you captured the photo correctly, but sometimes your white balance will accidentally come between you and a unique shot opportunity. In those cases, it's good to have a little backup.

From the Adjustment Layers menu, you have several opportunities to change the color in your image. If your problem is over- or under-saturation, try the Vibrance layer.

Here, you'll be able to make subtle adjustments to color using the vibrance slider, which won't completely blow out already saturated colors such as red and yellow that appear in your image. You can try the vibrance slider in conjunction with the saturation slider; as always, discretion and moderation are key.

Another color adjustment layer is called Hue and Saturation. This layer will give you three sliders to play with: Hue, which will shift all the colors in your image; Saturation, which will increase or decrease saturation; and lightness, which will lighten or darken your photo. This layer also has a Colorize option. If you select that option, you'll be able to work with your image as a monochrome.

The Color Balance adjustment layer is great for when your white balance settings have betrayed you. Using its three sliders for cyan/red, magenta/green, and yellow/blue, you can shift the mid-tones, shadows, and/or highlights for your image.

For example, if your photo came out with a sickly blue cast, click on the yellow/blue slider and move it a bit closer to the yellow side. In addition to color correction, this layer can also be used to add warmth or coolness as an effect.

A Photo Filter layer will act a bit like a light gel, allowing you to cast a subtle or extreme layer of transparent color over your image. For color correction, a subtle warming layer can fix unintentionally cool tones, or vice versa. And you can give your images a hipstery splash of sunshine with a Deep Yellow photo filter. For subtler or stronger effect, use the Density slider in the layer window.

Also, as previously mentioned, you can try adjusting the colors using the Curves tool and isolating the red, green, or blue channels, depending on your needs and desired outcome.

"Here at Photoshop Disasters (PSD) we strive to present the best of the worst Photoshop. How does this happen? It starts with having a meticulous community of readers who endeavor to catch and find these disasters. Every day countless disasters are emailed to PSD but only a few go on to become true Photoshop Disasters."

- PSDisasters.com

Photoshop Disasters is a great example of finding and capitalizing on a humorous niche. This blog has gotten loads of attention throughout the internet— and not just from the typical photography-enthusiast group, because everyone can appreciate the bizarre results of over-the-top (or just badly done) Photoshop edits. Its subject matter cuts in the opposite direction of most photo blogs, highlighting incompetence and lack of technical skill in often high-level professional photo-editing jobs. It's light-hearted and easy to consume, and readily distributed across social-media outlets. It started with original research, but does a great job of illustrating how once your blog reaches a certain momentum, it can capitalize on the resources of its own readership to generate new content, because most new posts are emailed in by readers themselves.

Chase Jarvis has become a household name in modern photography for many reasons, not the least of which is his photographic talent. He started his own photography studio at a young age, and quickly built up an impressive list of clients. But a big part of his stardom comes from his excellent blog, which he started way back in 2006—early enough to establish itself as a leading resource for up-and-coming digital photographers.

There's an underlying excitement running through Jarvis' posts that is absolutely contagious, and a direct result of his clear dedication to keeping in touch with his readers and going the extra mile to update them with his projects and ideas. He frequently blogs from the road, offering behind-the-scenes tidbits about his work, and commenting on new developments in the photo industry. Indeed, his forethought in seizing on two big developments in digital photography contributed to his catapult to the top of the photo blogosphere: He was one of the first to give extensive feedback on the incorporation of HD video into DSLRs, showing what this new technology is capable of; and he is also well known for embracing the iPhone and mobile photography as a powerful new movement.

cropping & rotating

Simple fixes like cropping and rotating appear in even the most basic image-editing software. Here's how to find them in Photoshop.

To crop, look at your Tools menu on the left side of the window. Near the top, you'll see the crop tool, highlighted here:

Select this tool, and Photoshop will automatically set the crop to the maximum area of the image. From here, you drag the edges to isolate only the area you want to keep, and the excess will be dimmed. Once it's all set, just press Enter and the cropped image will be centered on the screen.

Rotating is at least as easy in Photoshop. First, open your image file, which might look something like this:

Click Image in the top menu of your Photoshop window. Select Image Rotation. From there, you'll be able to rotate or flip your image in any way you desire.

Image	Layer	Select	Filter	View
Mode				
Adjustments				
Auto Tone				
Auto Tone Image Size...		Alt+Ctrl+L		
Auto Contrast		Alt+Ctrl+L		
Auto Color		Alt+Ctrl+B		
Image Size...		Alt+Ctrl+]		
Canvas Size...		Alt+Ctrl+C		
Image Rotation...				
Crop				
Trim...				
Reveal All				
Duplicate...				
Apply Image...				

180°
90° CW
90° CCW
Arbitrary...
Flip Canvas Horizontal
Flip Canvas Vertical

photoshop actions

These are quick and efficient—but don't get carried away. The Undo option is your friend here.

Photoshop Actions are a Pandora's box for Photoshop newbies. They give you access to curated adjustment and other layers that will give your finished photo a special effect. All you have to do is click a single button; the Action "plays," and you're left with a fully edited photo. For any effect you can dream up, there's probably a Photoshop Action to achieve it.

To see available Actions, just click the Play button in your Photoshop window's left-hand menu. If you don't see the button, click Window in the top menu, then click Actions.

You can free Actions sets online for all kinds of effects. Download them, then double-click the Action file; it will automatically load into Photoshop.

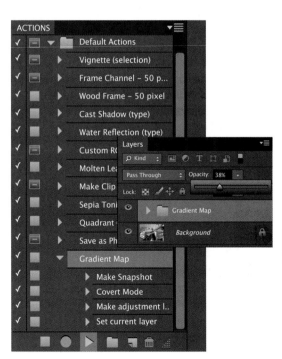

But even more than with other adjustments, make sure your Actions are coming from a reputable source. Heavy-handed actions can give an amateurish look. Also, using the same Actions over and over can make your photos look cookie-cutter. Induce some subtlety by packaging all the Actions layers in a Group, then turning down the Group's opacity.

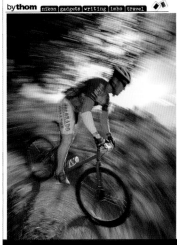

When photographer and author Thom Hogan says he's been around pretty much since the beginning of the internet, he isn't exaggerating. Deeply involved in the technology industry for decades, Thom Hogan has established himself as the leading online independent resource for Nikon shooters.

His blog offers everything from in-depth gear reviews to advanced commentary and reporting on industry news and events. His professional connections give him valuable insight into new technology developments, and his annual predictions for each camera manufacturer have become a staple of the photo blogosphere, inviting a cascade of commentary from elsewhere on the web. He's never afraid to voice his opinion, and his personality is tangible across almost every post—he clearly has high standards, for both products from manufacturers and images from fellow photographers.

He's also a great teacher, offering loads of advice (the rotating header image at the top of the blog always includes a detailed description of technique, and invites further commentary on G+), which then supports his workshops and extensive ebook sales.

135

watermarking

**If you'd like to brand your photos, Photoshop gives
you lots of easy ways to do so.**

However, keep in mind that watermarks will not
prevent people from stealing your photos. Determined
copyright infringers are one of the risks of putting your
work online.

Rather, a watermark may simply help others who
share your photos to passively give credit where it's
due. This might be useful if your images pop up a lot on
social sites such as Pinterest or Facebook without your
permission or knowledge; in those cases, a watermark
might make such "innocent" infringement a good thing
that helps to build your brand.

What won't help your brand is a big, ugly
watermark right across the middle of your photo—
and that also won't keep people from using your
images. Cleverer Photoshop users than you will use
other tools such as the Clone stamp or Heal brush
to wipe your watermark away in just a minute or two.
Instead, make your watermark a subtle bit of branding
in a corner or along the side of your photo; at least then,
others have the opportunity to appreciate your work.

If you have a logo already, you can always pop
the logo right into the PSD file by clicking File in the top
menu, then Place. This will let you navigate to your logo
image file, then will place that image as a new layer.
You can adjust the layer's size and opacity until you
have the watermark effect you want.

If you don't have a logo, you can create a new
watermark simply by using the Type tool. You'll find
it a little farther down in your left-hand Tools menu.

Click that, and you can click anywhere on your
image to create a new layer for typing text. You can
select the font and color of your choosing, and you
can change the size and spacing, as well. The text color
should contrast with the image enough to be visible.
If you choose a thick, chunky font, you can adjust the
type layer's blend mode and/or opacity as you please.

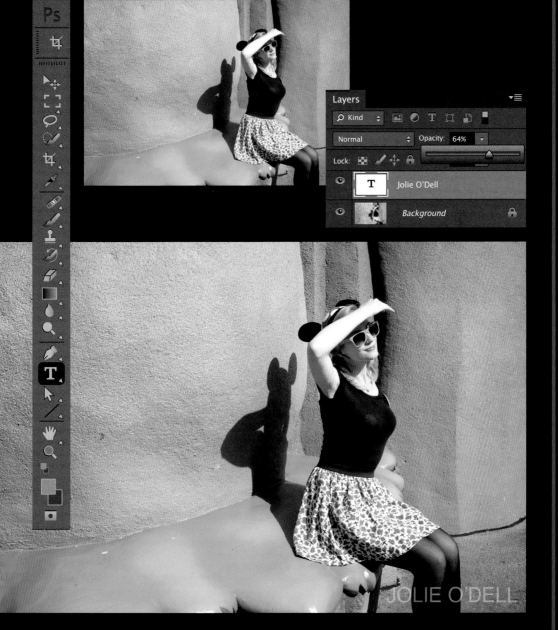

batch processing

**Believe it or not, this can be pretty fun
(in an extremely geeky kind of way).**

Taking what you now know about Photoshop Actions, you can start saving yourself a lot of time by automatically applying any action to a large set of images automatically. It isn't the best idea all the time—for instance, any time you are fine-tuning each individual image, tailoring your adjustments using your creative judgement as you go, Batch Processing won't be suitable, as it won't distinguish between your various images. But if you need to quickly resize a whole shoot to web-ready JPEGs, add watermarks, or fix a set of accidentally underexposed shots, Batch Processing can be a godsend.

It all starts in Adobe Bridge—Photoshop's File Manager that lets you preview each of your image files as thumbnails, complete with metadata and exposure info. It's an extremely versatile tool in itself, and integrates seamlessly with Photoshop in a number of different ways. For now, we'll concentrate on its Batch function.

First, highlight the images you want to Batch Process, and go to Tools > Photoshop > Batch. [1]

This brings up the Batch menu window, in which you can specify the workflow of the automated Action. At the top, in the Play box, you'll select which Action you want to apply to all your highlighted images. There are a series of default Actions in the list, but if you want to carry out a customized Action that you've created yourself, you'll need to create it first, in Photoshop,

before it will appear in this list. Fortunately the most recently created Action appears at the top of the list, so it's easy to find. [2]

In the next box, you'll almost always want Bridge to be your source (where you just highlighted your images). You'll also usually want to check Override Action "Open" Commands, unless you're using a customized Photoshop Action that specifically includes "Open" as part of its series of actions—otherwise, none of your images will open in the first place! You'll also usually want to check Suppress File Open Options Dialogs and Suppress Color Profile Warnings, as these alerts will constantly interrupt the workflow requiring your input, which sort of defeats the whole purpose of automating your process anyway.

Finally, you'll want to specify the destination of your images. You can save them as the same file with the same filename in the same place, or rename them and relocate them in a different location. You'll usually want to do the latter, to ensure that your original files are safe for archiving.

Before you start your batch process, it's a good idea to do a test run on just 2 or 3 images first, to see if the adjustments are made correctly, and the files saved in the right place. If it passes that test, highlight all your images, click OK, and watch the windows and dialog boxes fly across the screen at lightning speed. It's an incredibly satisfying experience!

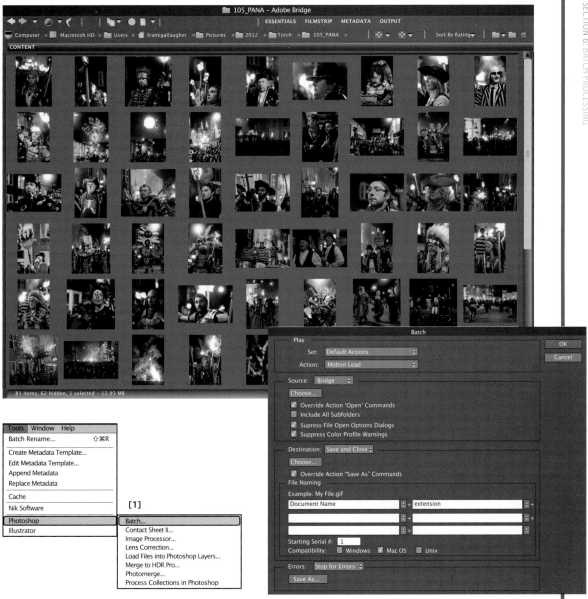

[1]

[2]

special effects

So far, we've talked about image optimization; but Photoshop can also be used for creating completely new images.

Sometimes you want to go beyond simple image editing; as a blogger, you will want your photos to occasionally act as illustrations, as well. In these moments, think of yourself as a magazine designer or editor. The photo is your starting point and your inspiration; what you create should be coherent but must continue telling the story for your readers.

For example, say you run a small photo studio, and you shoot a lot of engagement and wedding sessions. You're blogging about a recent engagement session, and instead of just showing all the photos in a gallery dump, you want to highlight the best, most distinctive photo as a "cover" photo for your post.

You can create all kinds of special effects—adding thin rule lines around the edges, inserting semi-transparent flourishes, etc. In this case, you chose to go with a barely-there white rectangle, created in a new layer from the Shapes tool in your Tools menu and adjusted to the correct opacity: [1]

Then, you selected the Eyedropper tool to pick a specific color from the original photo. You really liked the green stone in the center of the ring, so you picked a shade from that part of the photo and used it in the text: [2]

The fun doesn't stop there; you decide you like the contrast of the cool-colored ring with another image from the same shoot featuring fiery roses. So you create a mini-collage as your "cover" photo: [3]

Together, the design elements and the grouping of images help you tell the story of this blog post. You might not use special design tools like these for every post, but your readers will love them.

[1]

[2]

[3]

Ps

online tutorials

Remember your community! Countless other bloggers just like you are sharing their Photoshop know-how every day—so make use of it (perhaps with a link back as thanks).

All of these techniques are just the beginning of how to use Photoshop as a photo blogger. Any time you get stuck with a photo or need to know how to do something with your software, use a search engine such as Google to find what you need.

For example, if have a great picture of a bunch of vintage children's toys, and you think it'd be cool to give it a Lomo effect, search the web for terms like "Photoshop CS6 Lomo tutorial." That will lead you down a glorious rabbit hole of step-by-step guides with sample illustrations as well as detailed YouTube screencasts that explain every click and drag of the whole process (the images below took five minutes).

Best of all, this information is available free of charge to the curious. If you get good instruction from high-quality sources, you could end up with roughly the same knowledge and skill set as a design school graduate.

Granted, not all of these tutorials will yield the most elegant results; stick to reputable sources that yield classic, dignified-looking end results. And remember that not every new trick you learn can or should be applied to every image you snap. Some of the best, most inspiring photos on the web are those that are entirely unedited and unfiltered; as a photographer, such work should always be your goal.

"Join Frederick Van Johnson, Alex Lindsay and friends each week as they discuss camera technique, technology, and news. From taking photos of the family to understanding how cameras work to testing state-of-the-art equipment."
-TWiP (This Week in Photography)

This Week in Photography is a regularly scheduled podcast that interviews some of the biggest names in the industry, explores the hot new topics, and speaks in a language photographers recognize and appreciate as their own. They have a number of official hosts and co-hosts, but just as frequently they invite guests onto the show to provide their commentary and insight. The topics cover the full spectrum of photography, but what makes TWiP special is the authenticity of the conversation—the hosts all feel comfortable voicing their opinions in a way that makes you feel like you're just hanging out with them over a coffee or beer after a hard day's work in the studio. That casualness and earnestness works to engage readers and listeners in topics they might not otherwise have a huge interest in—obviously supported by the audio format of the podcast, but also maintained by lots of feedback and discussion in the comments.

143

resources

It goes without saying that the vast majority of the resources that will help you and your blog flourish are waiting on the other side of the search window. When you hit a wall, often the first step is to type your problem into Google and see what comes up.

That said, it's valuable to have some foundational resources that you can count on as reliable and authoritative. A lot of the sites you'll find in this section have been referenced throughout this book, and you're likely already aware of, if not fluent with, many others.

My best advice is to use this as a starting off point—take a look at these sites and services to explore your options and make sure you're taking advantage of all the resources that are available to you.

web hosting

GoDaddy: http://www.godaddy.com/
The largest web registrar and hosting company around, with lots of options for features and customer support.

iPage: http://www.ipage.com/
Low price and quick to set up, good for bloggers and small businesses.

Fat Cow: http://www.fatcow.com/
Good for newer bloggers and website owners, inexpensive with good customer service.

JustHost: http://www.justhost.com/
Its easy-to-use interface is perfect for beginners.

BlueHost: http://www.bluehost.com/
Speedy website setup and the ability to add premium site builders, including a one-click WordPress setup option.

Web Hosting Hub
http://www.webhostinghub.com/
Unlimited email and superb phone support for new or experienced bloggers.

HostMonster: http://www.hostmonster.com/
Quick customer support via phone and unlimited email; high-grade enough for pro bloggers.

custom blog design

SMITTEN
http://www.smittenblogdesigns.com/
Modern, fresh, pretty designs from an experienced design shop. Affordable options for smaller design elements as well as full blog design.

THE PIXELISTA
http://thepixelista.com/
A female-focused shop for design, hosting, support, and other services for bloggers.

BLOGGER BOUTIQUE
http://www.bloggerboutique.com/services/
A sliding price scale for services from a simple design overhaul to a custom "blogsite" WordPress installation.

DESIGNER BLOGS
http://www.designerblogs.com/
Customized blog designs as well as prefab designs for personal and professional bloggers.

JUNE LILY
http://www.junelily.com/
Packages that include e-commerce WordPress installations for setting up an online boutique along with a blog.

ELANCE
https://www.elance.com/
Hire a freelance designer/developer to work directly with you, creating a custom website and handling any or all of the ongoing technical management for you.

147

software

BLOGGING SOFTWARE

WordPress: http://wordpress.com/
or http://wordpress.org/ for self-hosted blogs
The most popular blogging software; also a robust
website framework and SEO friendly. Free & paid
versions, unlimited design options.

Blogger: http://www.blogger.com/
Google-made, web-based blogging software.

Movable Type: http://www.movabletype.com/
Six Apart's CMS for websites and blogs.

Typepad: http://www.typepad.com/
Pretty designs with a built-in affiliate program
for revenue.

Tumblr: http://tumblr.com/
A lightweight, highly social platform for blogging,
mini-blogging, mobile blogging, and micro-blogging.

Squarespace: http://www.squarespace.com/
Beautiful templates with photographer-friendly focus
on images.

PHOTO-EDITING SOFTWARE

ADOBE PHOTOSHOP
http://www.adobe.com/products/
photoshop.html
The gold standard, and priced accordingly. Free 30-day trials available. Extremely robust tool for photo editing, appropriate for web or print publishing of photos.

ADOBE PHOTOSHOP LIGHTROOM
http://www.adobe.com/products/
photoshop-lightroom.html
Good for quick image correction and for keeping track of a large catalog of images.

APERTURE
http://www.apple.com/aperture/
Apple's Lightroom competitor. Mac only.

THE GIMP
http://www.gimp.org/
The free-to-use and open-source answer to Photoshop.

PIXLR
http: //pixlr.com/editor/
An online editor that runs in your browser; good for quick fixes, especially when your own computer and software are not available.

MOBILE APPS

CAMERA+
http://campl.us/
Made by a photographer for photographers. iPhone only.

VIGNETTE
https://play.google.com/
(search for "Vignette")
Allows you to combine and layer effects, manipulate frame sizes, and more; flexible and robust. Android only.

social media glossary

FACEBOOK
https://www.facebook.com/
Allows you to build a personal profile and a professional Page to highlight your photography. With more than one billion users, it's the world's largest social network.

TWITTER
https://twitter.com/
Send short messages and small pictures to fans who "follow" you; you can also follow and share messages from famous photogs or others you admire.

INSTAGRAM
http://instagram.com/
A mobile app and social network where amateurs share images from their lives. Can be a great place to show off your quick mobile snaps with a public audience.

PATH
https://path.com/
A mobile app for connecting people with only their close friends and family; not for self-promotion or marketing.

PINTEREST
http://pinterest.com/
A social site where users "pin" interesting images they find around the web. Their collections are called "pinboards."

REDDIT
http://www.reddit.com/
"The front page of the internet," where users share interesting pictures and links. Users can "upvote" content; the more popular items get loads of traffic.

IMGUR
http://imgur.com/
A popular way for internet users to simply and quickly share images.

FOTOLOG
http://fotolog.com/
A photo-focused social network popular in Latin America and Spain.

CINEMAGRAM
http://cinemagr.am/
An iPhone app where users capture, filter, and share short, animated pictures.

150

GOOGLE+
https://plus.google.com/
Google's rapidly blossoming social network; a popular place for photographers. Known for its Hangouts feature, which lets users do live video chats with one another and in groups.

WEIBO
http://weibo.com/
China's version of Twitter.

MYSPACE
http://www.myspace.com/
Once a very popular social network, Myspace is now a destination for "social entertainment." Its future is currently in flux.

YOUTUBE
http://www.youtube.com/
The most popular online site for videos. Users can watch, "like," and share video clips. A great source for finding tutorials— or for making your own.

COUCHSURFING
http://www.couchsurfing.org/
A social network for lifestyle travelers— usually those on a budget and looking to "couch surf" their way to exciting new destinations.

RENREN
http://renren.com/
Chinese general social network; similar to Facebook.

deviantART
http://www.deviantart.com/
A community for artists, photographers, and graphic designers of all experience and skill levels.

FLICKR
http://www.flickr.com/
Users can upload and "favorite" images. Images can be grouped together in Galleries, Collections, Sets, and in Pools by Groups, which are communities based on location or topic.

FOURSQUARE
https://foursquare.com/
A network for sharing checkins and images based on your location.

YELP
http://www.yelp.com/
A network where users read about and review local businesses, including restaurants.

ORKUT
http://www.orkut.com/
A general social networking site owned by Google and popular in India and Brazil.

STUMBLEUPON
http://www.stumbleupon.com/
Proactive users can browse the web and "stumble" the pages they find interesting. Later in a more passive experience, other users will see the same page as they browse through interest-based collections of pages on StumbleUpon. Great images can help a page get stumbled.

glossary of blogging terms

"above the fold" Placing an eye-catching headline or some other form of content where it will be seen in full on-screen, without the need to scroll down—usually means taking into consideration the average size and resolution of computer screens.

archives All your old posts, organized usually by date, but also by tag or category. Often exists as a sidebar.

banner The horizontal visual element at the top of your blog, which may or may not be repeated throughout all the subpages and topics, and may or may not also serve as the header or navbar.

blog carnival A blog post that contains numerous links to recommended content on other blogs, typically concerning a specific topic. *See also* link love.

blog client The software used to manage your blog, typically synonymous with your CMS.

blogathy A portmanteau of "blog" and "apathy" that applies to those days where you just can't get motivated to post, or worse, when you start losing faith and/or direction in your blog.

blogiday A well scheduled, publicly announced, and temporary holiday from your blog.

blogger That would be you! The primary caretaker of a blog, responsible for the majority of its content. Can be supported by "guest bloggers."

bloggies Nickname for The Weblog Awards—annual, non-profit awards that judge the best blogs in a wide variety of categories.

blogroll A list of blogs, often presented in a sidebar, that the blogger recommends to readers. Can be on a similar topic, or simply that particular blogger's favorites.

blogosphere The totality of all the blogs on the internet, and the community that exists among them.

blogware A portmanteau of "blog" and "software," simply referring to any sort of software on which a blog runs—such as Wordpress or TypePad.

bounce rate The rate at which readers visit your blog, only to quickly leave ("bounce") and go somewhere else. Lower bounce rate numbers means better quality traffic, as your readers are lingering and taking the time to consume your content.

CAPTCHA A test used by many blogs to decrease spam by requiring a user or reader to prove they are human before commenting on a post or participating in some way. Typically they are asked to transcribe a distorted image of text. It is an acronym of Completely Automated Public Turing test to tell Computers and Humans Apart.

categories A series of topics into which you can divide your content, for ease of navigation on your blog— particularly in archive posts.

CMS (Content Management System) A software program that facilitates the creation, editing, and publishing of content—typically text and images (a blog post) online. Much of the function of a CMS is to simplify your blogging workflow and avoid going "under the hood" too often and directly interacting with the source code.

collaborative blog A single blog supported by multiple bloggers, who typically all share responsibility for the blog's content and upkeep.

comment spam A comment that seeks only to lure readers into clicking its link, typically to take them to an advertisement or commercial site somewhere else.

CSS (Cascading Style Sheets) A software method of managing the theme and overall appearance of your blog, in which changing one element (e.g., the background color) affects all similar pages throughout the blog.

dashboard Think of this as the control center of your blog. Typically the first screen presented after sign-in, from here you can create new posts, manage old ones, change visual themes, moderate comments, and so on. Often customizable, depending on your blogware.

desktop blogging client Software that allows you to manage your blog without using a web browser (it being installed and running on your computer or "desktop").

domain The main page or index URL of your blog— typically it is also the blog name.

feeds *See* RSS feeds

flame An intentionally hostile and/or provocative comment or post that is primarily meant to agitate another person or party (typically a fellow commenter or blogger). If left unchecked, a series of flames can start a "flame war" in which most other discussion is completely stifled by the back-and-forth between quarreling parties.

footer The horizontal stretch of space at the very bottom of your blog, which usually has navigation links to other parts of the site, such as an About section or a copyright statement.

FTP (File Transfer Protocol) A method of transferring very large files over the internet. Often supported by desktop software, it is an excellent way to transfer large batches of images and other content from your desktop to your blog's server.

header The horizontal stretch of space at the very top of your blog, which typically includes a graphic of some sort (e.g., a banner image), and multiple navigation links to important other places throughout your blog. This almost always includes your blog's name or title.

hits A common term for the number of views or visits a particular blog or post receives in a given amount of time. The more hits over the shorter amount of time, the more popular your blog is, and the more valuable it is to potential advertisers.

HTML (HyperText Markup Language) The "under the hood" computer language that determines how text and other elements are visually displayed on your blog. Typically your CMS affects the HTML without your having to directly make changes, but also offers the ability to write HTML yourself for advanced options.

hyperlink A method of sending your readers to another website by having them click on a certain colored (typically blue) word or phrase, rather than giving them the full URL and having them copy and paste it into their browser window.

index page The "front page" of your blog—the first place a reader will go to after going to your URL.

jump The breaking up of a blog post into two parts, to insert space for an Ad, another post, or a visual of some sort in between. Typically announced within the blog post by saying "more after the jump," indicating the post will resume below. Think of it as the blog equivalent of "and now a word from our sponsors."

keywords Words applied to the metadata of a post in order to identify its relevance in search engine results. Different from tags insofar as tags are mostly used for organizing the post into separate topic pages within the blog itself, whereas keywords are more concerned with outside search results.

link love Linking out to multiple other blogs from your blog, without any direct or immediate expectation of returns, but rather in the spirit of "what goes around comes around."

lurker A reader or visitor who consumes content but always anonymously and never contributes to the discussion by commenting. Typically the majority of your readership are lurkers, but the idea is to entice them into become active participants.

metablog A blog about a blog; or a type of blog post in which you discuss your blog itself, the blogosphere as a whole, or in some way make the topic of discussion blogging itself.

metadata Information you add to each post, typically "under the hood," that carries information about the post itself—such as tags, publishing time, author, etc.

moblog A portmanteau of "mobile" and "blogging," signifying (you guessed it) mobile blogging or "blogging on the road."

navbar Short for "navigation bar," a series of links organized into the different sections or topics within your blog, such as your About page, Contact page, etc. Can be a sidebar or part of the header.

newbie A slang term for a beginner, inexperienced in the particular community in which they are now participating. Also called newb, noob, the term was originally pejorative but has taken on a more colloquial quality.

niche A particular subset of a larger group, with shared interests and topics of discussion. For instance, within the totality of the photo blogosphere, there are particular niches of wildlife photographers, mobile photographers, citizen journalists, etc.

newsletter An email sent out to subscribed readers of your blog, typically on a set schedule (e.g., monthly). Can serve as a summary or digest of your blog's content, or have original content not found on your blog.

nofollow Tags that you can apply to links in a post that discount that link from contributing to search engine results or page rankings. Recommended for outbound links going to content that you do not recommend or do not wish to be associated with.

page rank Google's method of measuring the quality and significance of a given page. The higher the page rank, the more frequently Google will display that page in relevant searches. Page rank is affected by a number of factors, most of all the number of outside pages linking into that page (i.e., if a page is very popular elsewhere on the internet, it is probably of high quality).

permalink A URL that directs to a specific blog post. Once older blog posts can no longer be viewed on the index or homepage of your blog, you can direct readers to them by using that post's permalink. As the name indicates, it cannot be changed once the post is published—even if the title of that post is changed. *See also* redirect

photo blog Originally the term applied largely to blogs that exclusively featured photography, with little or no text in each post. But more commonly it now applies to a wider range of photography-enthusiast blogs covering the gamut of photo-related content.

photofeed A feed or widget that displays a series or gallery of images—often taken from a referenced galley on another image-hosting site such as Flickr.

pingback A method of automatically finding out when someone else links to content on your blog.

platform *See* blog client *and* CMS

plugin A file or program that expands the features or functionality of a given program, used in blogs to add new components to an existing blog platform.

podcasting Any method of publishing multimedia content online, often streaming and as part of an ongoing series. The term originally comes from the frequency at which audio content is listened to on iPods, but it is not at all limited to that device.

post The heart and soul of your blog—equivalent to an article in a newspaper or magazine. Each post is typically a discrete unit (though they can be strung together into a series), with its own permalink, on any topic you wish. Can be any combination of text and media.

redirect A method of automatically directing readers from one URL or permalink to another. For instance, if you establish a new URL for your blog, but want to migrate over all your existing traffic, you can set up a redirect so that anyone visiting your original URL automatically arrives at your new URL.

RSS (Really Simple Syndication) A way to simplify and expedite the consumption of content from multiple sources (such as blogs). By subscribing to the RSS "feed" of a blog, new content published on that blog will automatically be sent to the reader, negating the need for them to visit each blog individually.

SEO (Search Engine Optimization) Any number of tactics used to elevate your blog's standing and ranking in search results, which in turn should increase your readership. Common SEO tactics include meticulous tagging of posts (making them easier to find in relevant searches), aggressive social-media marketing (to increase links back to your blog), and general publicity.

sidebar The vertical stretch along either the left or right side of your blog. It often serves as a navbar with links to other parts of your blog, or can serve as a blogroll with links outward.

sitemap A discrete page within your blog that visually represents all the separate pages of your blog, typically containing links to each of those pages.

spam Unsolicited messages, comments, or email sent en masse to large numbers of outlets, typically for advertising or marketing purposes (which themselves are usually scams). Spam is an unavoidable facet of online life, but careful moderation and anti-spam plugins can mitigate its distraction.

slashdot effect An ironically troublesome issue, in which a popular outside site—such as the technology news site Slashdot—links to your blog's content, driving such a huge amount of traffic your way (which is a good thing) that your blog is overloaded and becomes slow or crashes entirely (which is a bad thing).

subscribe An option presented to readers that allows them to automatically receive notifications when your blog's content is updated—typically via an RSS feed. May also apply to your blog's newsletter.

tags Often used interchangeably with categories, tags are applied to the metadata of posts and articles so that they can be found later under their respective navigation topics, and also located easily in a search. While it's important not to go overboard on tags, judicious and regular use will help your posts gain traction in search results.

tag cloud A visual feature often included in blogs on the sidebar that represents all the tags used throughout the posts in that blog, with extra weight given to the tags used more frequently. The idea is that it gives a good overview of the topics discussed on that blog at a glance.

templates A prepared, "off-the-shelf" design format that you can apply to your blog in order to avoid dwelling too long on design decisions.

theme A holistic view of your blog design that takes into account all the visual elements on each page, affected and adjusted by your CSS (Cascading Style Sheets).

thread An ongoing discussion or conversation that occurs in the comments section under a post on a particular topic (i.e., the "thread" of discourse).

trackback A notification that someone else has referenced your blog on another site, even if they haven't directly linked back to your blog (in which case you would receive a pingback).

troll Although the typical interpretation is the type of nasty monster that lives under a bridge, the origin of the term comes from the fishing technique of dragging a baited hook behind your boat, hoping to attract a school of fish. The internet troll is a combination of both these terms—an annoying commenter who posts provocative, controversial, or just plain nasty comments with the intended purpose of baiting other commenters into engagement, and distracting from the intended topic of discussion. The best tactic is to ignore them (i.e., "Don't feed the troll!").

URL (Uniform Resource Locator) The address of your blog or some subsection of it on the internet, which readers can type into their browser in order to arrive at your site. Your blog will have its own primary URL, which is typically the blog name as well, with each post having its own unique URL called its permalink.

vlog A blog post that consists entirely of video content—often a direct address of the blogger to their readership.

weblog The origin of the term "blog" that no one uses anymore, having dropped the first two letters.

widget An off-the-shelf piece of software that can be plugged into your existing CMS to add a feature, and are typically located in a sidebar (e.g., a list that automatically updates with your most popular posts, or an interactive connection to your social media outlets).

index

acknowledgements

Special thanks to all the bloggers referenced
and featured throughout this book:

StuckInCustoms.com
blog.MingThein.com
Pixiq.com/contributors/Haje
TheSartorialist.com
Strobist.blogspot.co.uk
VisualScienceLab.blogspot.com
TheOnlinePhotographer.com
CalvinHollywood-blog.de
Focus-Numerique.com
PetaPixel.com
SLehmann.de/LD
Blogs.Adobe.com/JNack
SteveHuffPhoto.com
ShutterSisters.com
RebekkaGudleifs.com/blog
PekkaPotka.com/journal
ImagesFromTheEdge.com/blog
blog.Reflex-Photo.eu
Lens-Flare.de/blog
Rafalrusta.com/blog
MarcoCrupiFoto.blogspot.co.uk
ParisDailyPhoto.com
PSDisasters.com
blog.ChasJarvis.com/blog
ByThom.com
ThisWeekInPhoto.com